ARTISTS'
SURVIVAL
GUIDE

Published by Grey Tiger Books

GTB, 10-16 Ashwin Street, Dalston, London, E8 3DL

First Edition
Copyright © 2013 Grey Tiger Books
All rights reserved

A catalogue record for this book is available from the British Library
Designed by Zoë Anspach
Edited by Tara Cranswick
Compiled by V22

V
2
 2

In collaboration with V22 Young London 2013.
Young London 2013 is supported using public funding
by the National Lottery through Arts Council England.

ISBN: 9780956441980

To contribute to the second edition of *Artists' Survival Guide*,
please email hints and tips to: asg@greytiger.co.uk

CONTENTS

+ use right-hand navigation

CONTRIBUTORS

ACME	Elinor Morgan	KS Objectiv	Pyronox
Adam King	Emmanuel Boos	Kyriakos Iordanis	Rebecca Holborn
Alana Kushnir	Fergal Stapleton	Lee Jones	Reshma Gumani
Alex Holroyd	Gaelle Tavernier	Leyla Folwell	Richard Gasper
Alex Peake	Gareth Polmeer	London Mould Makers	Ron Henoq
Andie Brown	Gavin Wade	Loran Dunn	Ruth Claxton
Anna Moysi	Helen Frossi	Lucy Beech	Scott Mason
Anna F. De Paco	Islington Mill	Matt Blackler	Shahin Afrassiabi
Anna Tjan	James Wright	Matt Fitts	Shirley Shaw
Ben Cade	Jamie-leigh Hargreaves	Maurice Carlin	Soundfjord
Bhavya Gala	Jane Carroll	Mauro Saccardo	Spike Island
Bonita Alice	Jane Lawson	Max Leonard Hitchings	Stephenie Choy
Caro Halford	Janice Macaulay	Natalie Bradbury	Sue Stephens
Castlefield Gallery	Jess Walters	Nisa Sanchez	Susanne Dietz
Charlotte Hetherington	John Jones	Noe Baba	Tara Cranswick
David Leister	Jonathan Harvey	Noleen Read	Tavia Davies
Debbie Duffin	Jonathan McLeod	Oaksmith Studio	The Block
Douglas Lamond	Jung in Jung	Oliver Bancroft	Tim Ridley
Eastside Projects	Katy Dickens	Oliver Weston	V22
Eira Szadurski	Kenneth Graham	Pascal Nichols	Zoë Anspach

I would like to point out that I am not the only 'I' in this book – there are several – but herewith, a personal note from me.

I have thoroughly enjoyed compiling and contributing to this book. I hope it will prove useful to you. I realise that it is missing many things and that the directories are not all-inclusive, but we have gone on direct recommendations, which we felt was the best way to be the most useful. I hope you shall consider contributing to the second edition and help us to compile an even more comprehensive guide to getting along as an artist.

We have steered wide of anything which even attempted to tell you how to make art. That is your magic, and in any event is not something which can be learned in this format. This is rather a compilation of suggestions and things to think about which may make the going easier, or expand your thoughts on possibilities.

This book has been made possible by many people, but there are some I would like to thank who are not listed to my left, but who, through imparting their practical knowledge to me, have made their way into the book indirectly: George Coutavidis, Tom Rowland, Charles Saatchi, Kim Savage, Dom Beattie, Phyllida Barlow, Adam Thomas, Micky Cashman, David Rowett, Natasha Plowright, Henry Lydiate, Peter Stork, Sarah Ballam, Paolo Vigna, Mat Jenner, Conor Kelly, Chris Shaw and David Thorp.

All the best to you, and if I may add a final tip - for when things are bad: spit on the floor and call the cat a bastard.

Tara Cranswick

INTRODUCTION

Bonjour!

It is possible to make art.

It is possible to look at art.

It is possible to see art.

It is possible to think about art.

It is possible to speak about art.

There's a part of the process of making art which repeats itself with each new work or series of works – the beginning, often long drawn-out – that is lonely and frightening. Don't avoid this part. This is where the special stuff happens. Art starts from almost nothing and is made of almost nothing and is about hardly anything at all, and if you're really careful, patient and brave, and you stay with it, and you don't force it, you'll be able to coax it into being and it will be tremendous.

But then look at all this below, all these blockages and hindrances and nonsense that are going to spring up in your face wherever you turn... Beware!

1) Artists get picked up for shows and by galleries ever earlier in the learning process. This is not good for art as it overrides the delicate and necessarily private developmental stages. Well, you can hardly say no to any attention you get, but you should try to mitigate the damage by continuing to privately think very seriously about how your art should develop.

2) It's also no good for art, this business of artists letting others tell them what to make. Choosers for exhibitions often do this as they wrongly imagine that art is subservient to their arrangements of it. In any worthwhile reality, it's no-one's job to make fragmentary components for themed shows. In the same vein, if and when the time comes, avoid the plague of those templates and briefs that people may send to you to 'respond to' (ie to fill in with something vaguely resembling your art) for charity auctions and other art-degrading stunts.

3) When you see that someone is working against you, insisting on asking irrelevant questions, trying to steer you in wrong directions, use steady patience. If you have taken great care to develop your relationship with your art, you'll be the sole authority on the matter, and you can calmly show them who's who and what's what.

4) People often start firing questions without having looked sufficiently at the art. The obvious answer then is for them to look at the art. There is nothing hidden in art, it's all there, perfectly visible, including the precise level of any 'hiddenness'. Even if in consequence of the developmental stage you're at, the finished work has

only really got halfway there, its halfway-thereness is apparent. This means you shouldn't be doing a lot of explaining.

This also goes for reviewers. They have no business needing to speak to you for the purpose of finding out what your art does. If they do, this means they don't know the first and most important thing about their job.

5) In a similar vein, the non-existent categories of 'viewer' and 'audience' will be bandied about. Avoid these falsehoods which are promoted to divert your art away from its path and towards some second-guessed vagueness about how it might be received by other people. What's important is not a general idea of people, but those specific and complex mental mechanisms that correspond to the actual workings of art.

6) Often people will get keen about 'reading' your art. Works of art cannot be read. Those attempting to read art (beyond the labels and any written content) will immediately wander into irrelevance. Art is visible, not readable. Imagine making the comparable error with books, and instead of reading them, you paid irrelevant attention to all those big grey rectangles made of tiny shapes. The only way to develop a relationship with art is by seeing it – which can only be done by looking at it (in silence, and for as long as it takes to see it). Those who have not trained themselves to do this are not qualified to pronounce the slightest word on any art anywhere.

For those inclined to argue the obvious fact that you must also know a lot of things that aren't in the art: what, I wonder, do they think Seeing means?

7) Art is not something else. Art does not have to adapt to any general expectation of it. Art is a specialism exactly like mathematics in that if someone is interested, they'll go to it to find out what its terms are. Try and imagine the pure stupidity of changing the rules of quantum physics to appease stubborn ignorance. Same with art.

If, in heeding these warnings, you show you are a friend to art, then you can be my friend too.

Bon chance!

Fergal Stapleton

MAKING

DECIDING ON A STUDIO

A STUDIO DOES NOT MAKE YOU AN ARTIST

- It is an ongoing significant financial commitment which means not investing in other areas of your practice.
- There are several studio organisations which offer affordable space. They are affordable because a) the studio provider has been going a long time and secured freeholds or long leases; OR b) the providers are taking advantage of short leases before developers move in and handing on the saving to artists.
- Affordable studios are usually run by people for the love of art. A NFASP report estimated they subsidise the visual arts in England by £16million every year, so don't treat them like a dodgy landlord/rubbish removal service. Treat them like partners – we need them!
- It can take years to get a permanent studio (esp. in London) so sign up for a range of waiting lists even if you don't know where you will be living in the future.
- Do some research and compare what different providers offer. Do you like the organisation? Do you like the people? Are there professional advantages to being with one organisation over another?
- What is NOT included in the rent? Find out about any additional charges and get a clear idea of running costs. Heating, lighting, water, business rates, internet, service charges... these may be extra or may be included in the rent.
- Studio providers usually charge an inclusive rent – one that covers everything (sometimes excluding utilities). The rent charged by a commercial provider is unlikely to be inclusive.

- READ THE LEASE/LICENSE. Every word. At least 3 times. Make sure that you understand all clauses and responsibilities. There may be limits on materials you may use, what access you have, insurance, subletting (don't assume you can do this), giving notice, what happens in the event of rent non-payment. If you agree anything verbally, add it to the lease agreement or confirm it in writing.
- Don't take on more than you can afford. It's demotivating and depressing when you find you have to work the 'other' job for so many hours that you have no time or energy to visit the studio which it's paying for.
- Check how much notice you will need to give before you can leave. Most studio providers offer one/two months' notice, which is nice and flexible.
- Few artists use their spaces all day, every day. Consider sharing/time-sharing.
- Taking on a space that isn't ideal, temporarily, can be a way into a studio building, and tenants often get first refusal on better spaces.
- Studio organisations may offer short-term vacancies long enough for you to complete a specific project or commission (i.e. 6 months).
- If you are ever offered a permanent studio, take the chance to occupy it! Ask your landlord about notice periods. Have in mind that you can give it up at any time. There might be other options (subletting) for when you travel or do not need it.

We believe that if the art of today is complex and demanding then the places that we conceive for producing and experiencing it should reflect this.
Excerpt from Eastside Projects User's Manual: Draft 5, 2012

STUDIOS

Be Safe

- Be security-conscious – it only takes one artist to be lax and everyone's security is compromised. Shut and lock doors behind you and never label your keys.
- Use resin and stinky stuff outside – others don't have to accept your health and safety choices.
- Always leave painting rags in a metal container – these can start fires and have been known to spontaneously combust – so never store in a wood or plastic bin.

Be Comfy

- Split the studio and install some type of storage/painting rack/shelving. This is well worth the investment: more space, more organised, prevents finished work from being accidentally damaged, and makes it easier to tidy up for visitors.
- DIY double-glazing: during winter, apply double-sided sticky tape/staple gun a taut layer of cling film or polythene in front of the window. This works so well!
- Suspending a polythene ceiling also helps with warmth.
- Invest in a dehumidifier – keep your studio dry AND warm.
- Stop up ALL draughts especially under studio doors - save on heating. This makes such a massive difference.
- Get a good hand cream, especially in winter – avoid getting cracked artists' fingers. Wearing latex gloves when using turps/other substances can help too.
- Get a biscuit tin! Mice love studios.
- Please get headphones if you need to listen to loud music.
- Making art is a tough thing to choose to do in life; we don't have to make it harder for each other.

STUDIO DIY - GET YOUR OWN BUILDING

NEVER FALL IN LOVE WITH A BUILDING

- Work out the maximum you can pay, taking all costs into account, and if you are not sure, say 'NO'.
- If you are in a group, all members need to be reliable people who will do their bit.
- Make sure you are business-like in your dealings with potential landlords, agents, etc. and get to appointments on time. The clichés about artists still abound so best to prove them wrong straight away.
- If you are offered a property, get some experienced help looking at any tenancy / lease on offer.
- If a rent is suggested, what additional costs are there: insurance, service charges, business rates? What is the rent review procedure?
- Always worth asking for a rent free period – especially if the property needs some repairs. Negotiate!
- Remember that all space has to be paid for. If space is set aside for a meeting room/gallery/storage space/workshop, how will it be financed?

Rent review: Always check when the next rent review will be and how it will be calculated. If it is an 'open market' rent it means your rent could increase in line with similar properties. What is a low rent now could increase considerably.

Service charge: The service charge can be as much as the rent. Ask how much the charge has been in previous years. Ask if there are any major upcoming repairs that will be recharged through the service charge (worth asking for a cap on this).

Notice period: Check how much notice you will need to give before you can leave. If things go wrong, you want to be able to get out fast.

Rates: If your rent does not include business rates, you will need to add this to your costs. The rates are calculated using the rateable value which you can find at www.voa.gov.uk. Search by postcode to find the rateable value of your building.

Contact your local council / look online to find the correct multiplier. Check to see if you qualify for the small business multiplier. Multiply your rateable value by the correct multiplier to see what you will pay.

If you are a registered or exempt charity, you may be eligible for mandatory rate relief. Mandatory rate relief is currently 80%.

If the rateable value of your building is less than £12,000, you may be eligible for small business rate relief. Small business relief is 100% until April 2014, then 50%.

Some councils will consider discretionary rate relief where your artistic activity fulfils certain requirements. The requirements usually involve education and/or community engagement. Contact your local council for information.

If you get through all of that, it is amazing to have your own space.

Make your studio a place where you're really happy to be.

ACME

TOOLS – GENERAL

- Get your own tape measure!

 Steel tapes are best – a wider tape will be more robust and last longer.

 If you prefer only millimetres for measuring, you can get mm only tape measures in Europe. Nowhere in England sells them! Go to Italy or Poland to get one – when you go, get a few! The advantage is you can measure stuff from both sides of the tape – amazing how annoying it can be when all you can see is the inches side!

- When purchasing a drill, take into consideration the 'Ah' number of the battery. The higher the number, the longer it will last without having to be recharged. Always go for lithium batteries rather than nickel-cadmium.

- Smaller combination sets with drill and impact driver are great and will be good for most things – 10.8 volts.

- Never get a cheap drill – it is totally pointless. It will break.

- The best quality drills are made by Panasonic, Makita, Milwaukee, Festool and some Bosch.

- It is often cheaper to buy the drill body ('naked' drill) and batteries separately.

- SDS – for when your drill is not strong enough to drill into something.

- Don't buy a cheap spirit level – good to get a long one for hanging – can also be used as a straight edge.

- Jigsaws are just right for certain things, and solve many problems that most other cutting tools can't: cut a rough shape, cut through, a half-radius, geometric forms. You might not use them that often, but when you do, it saves loads of work.

- A good handsaw has 90 degree and 45 degree angles for you. Beware: cheap saws mimic the shape of the angles but they are not true.

TOOLS

- It is generally worth building up a collection of good power tools – build it up slower and have fewer, but make sure they're good.
- I find it useful to have a bad set of chisels; you will use them for a variety of things – screwdriver, taper wedges, wrecking bars, scrapers, levers.
- A hairdryer. Yes, a hairdryer. A really useful tool to have around the place when you want to dry something quickly or add a little controlled heat.

PAINT

OIL

Colours of oil paints dry at different rates because the pigments interact differently with the oil.

Fast: Flake & Lead Whites, pigments with manganese, Cobalts, Prussian Blue, Raw Sienna, the Umbers, the chromes

Medium: Titanium white, the Quinacridones, the pthalo blues & greens, Ultramarines, the Ochres, Burnt Sienna

Slow: Most yellows (chrome is fast-drying), the Cadmiums (red is slowest), Oranges, Alizarin Crimson, Zinc white, vermilion, most blacks (except manganese), madder

- Mix Liquin with genuine turps to make it less shiny.
- When you see paint that has cracked, it is usually for one of the following reasons (I am not saying don't do it, you may want to, but understand why it happens):
 ¬ Thicker layers of paint shrink as they dry causing thinner layers above to crack.
 ¬ Faster drying pigments over slower drying pigments will crack.

- Always mark/colour-code your paintbrushes, especially if you're sharing your studio with another painter!
- The more toxic pigments are those which include: cadmium; lead; cobalt, barium.
- Try cleaning brushes with sunflower oil – leave them in for a while and then wipe off. It removes the paint but doesn't dry them out as much as turps.
- If I want to save a brush with paint on it so I can use the same colour next day, I leave it in water overnight – it stops drying, and you can wipe off and carry on.
- Don't pour solvents down the sink!
- Recycle Turps/White Spirit: Pour dirty turps into a jar. Leave for a few days and the residue sinks to the bottom. Pour off the clean liquid into another jar. You can do this several times and have several jars – your turps keeps getting cleaner.
- To get rid of residue sludge from solvents – pour some cat litter into the jar – let the litter soak up the solvent, then it can be scraped out and put into a bin.
- Keep your painting rags in a metal bin – not wood or plastic – Fire Safety!
- Linen is really beautiful to paint on, is much stronger than cotton, and is the traditional choice, but Cotton Duck makes a good, less expensive alternative.
- The friction of a rough canvas actually helps to pull the paint off the brush so it's good for thick paint. At the other end, a really smooth surface is better for more control, so it's great for glazes and very fine and detailed work. Prime then sand several times to get the smoothest surface.
- Remember that if you use household paints, the colour really fades. It also discolours and becomes brittle.
- Never throw away old T-shirts – they are always useful as rags and cheaper than paper towel. Off-cuts of canvas can be used to rest dirty paintbrushes on.

PAINT

- Sweep your studio at the end of the day, allowing any dust to settle before you are next in – dust is a painter's nemesis!
- Make a list of the exact colours of paint you are running low on before going to the art shop to avoid returning with more duplicates than you had planned.
- When using spray paint, turn the can upside down and spray for a couple of seconds to prevent the cap from clogging.
- Use duct tape to repair holes in paint tubes – avoiding mess and paint loss. (Duct tape is really useful so it's good to have around in any case).
- Oil paint is simply the best medium for colour we have – enjoy it. Don't listen to any bloody rules – you will figure out what you want to do and how to do it.

STRETCHING

- You can stretch canvas over anything, but typically a stretcher frame or panel. Specialist stretchers are great, but you can make your own frames. Frames under $1m^2$ will not need cross bars to support them against the tension of the canvas.
- Try not to use wood which has knots or sap which eventually seeps into the canvas.
- If you're regularly stretching canvas, get a good quality, and branded, staple gun (so you can always purchase staples easily). Get something lightweight without too much kick. This will save your wrist from strain. The other option is an electric staple gun which has virtually no kick. Arrow and Rapid are good makes.
- If you have assembled an artists' stretcher-frame and want to make sure it is square, with a tape measure check that the diagonal lengths are equal. If they are not, lightly hammer the corners of the longer distance until they are both equal.
- Different people argue about ways of stretching, but the classic is: get the

weave parallel to the stretcher; start at the centre of each side (put in 3 staples for strength); work opposite sides after each other; pull just enough to create a diamond shape in the canvas where the centre staples stretch it; once all four sides are done, work outward on each side from the centre, equal spacing between staples and an even tension. Don't be tempted to stretch it more than one staple out each way before moving to the other side. Do your corners last.

- Stretching pliers can be used to get the canvas really tight, but ideally the tension should be equal along the sides, so don't go crazy in the centre and not be able to sustain that tension to the corners.
- If you don't want to use pliers, try wearing rubber gardening gloves or old leather gloves on large stretchers to avoid rubbing the skin off your fingers!
- If stretching over a panel, use a loose, open weave so the size does not get trapped under the canvas but can ooze through.
- Aluminium stretcher frames are brilliant for larger works – they are much lighter and do not warp.

PRIMING

- Oil paint eventually rots the canvas/linen. This is the main reason it needs to be primed, but you will also lose colour intensity over time if you don't prime.
- The work of a primer is to protect the canvas, but also to absorb the first layer of paint – bonding it with the surface and forming a good base.
- Canvas can be primed with anything inert – simple house paint will do, although it cracks over time and can also colour with age. PVA glue, watered down, can be used in a pinch, but this yellows. Neither of these is sufficiently absorbent.

- Remember your first layer of primer needs to be worked into the canvas. Don't apply too much pressure, but work the primer into the weave of the fabric – it needs to fill the gaps in the weave. The best priming brushes are wide with short bristles to help get the primer absorbed.
- It is always best to apply several thin coats – never one thick coat of primer.
- For a really smooth finish, sand the primer between applying several thin coats.
- Before finishing priming, hold the canvas up to the light – if you can still see pinholes of light then the primer is not properly protecting the fabric.
- Some pre-primed super fine linens are actually soaked in a primer to protect each thread – always ask your supplier about pre-primed fabric.

OTHER PAINT

Acrylic: acrylic molecules are bigger, and the medium very stable, so you don't have to size or prime your raw canvas, but can use the colour directly onto the canvas – very nice for staining washes.

- Acrylic can be used as underpainting for oils – if the underpainting protects the canvas sufficiently then you don't need to prime first.
- Acrylic on paper works well as the paint does not sink as much as oils do.
- Mixing different brands of acrylic colour can be tricky, so test first.

Gouache: pretty much an opaque watercolour.

- Can be mixed with watercolour.
- Can be mixed with acrylic, but do tests first – there can often be colour changes.
- Good for making areas of flat colour, which can be difficult with watercolour as you tend to see the brush marks.

Watercolour: no matter what you do, have a regular play with these – so lovely.

- Always use acid-free paper.
- You need to stretch the paper you will be using: soak the paper to expand the fibres; tape it flat to dry taut.
 - ¬ Soak the paper completely – up to 20 minutes for thicker papers
 - ¬ Drain off excess water
 - ¬ Lay paper over flat board with some water-proofing
 - ¬ Use brown gum strip (not masking tape) to tape edges along each side
 - ¬ Keep the board flat to dry
 - ¬ When paper is dry, remove and paint

OTHER SURFACES

Aluminium: If painting on aluminium, it needs to be etch primed: the panel is etched using acid to create a fine tooth so that the primer does not peel or crack.

Wooden Panels: Priming wooden panels can make them twist or warp. Prime the edges first as these are the most absorbent. For priming, the best is to use a subframe to hold the panel in place while you prime, and leave it in there until it is completely dry. If you are not too concerned, just paint a large cross on the reverse from corner to corner to counteract the worst effects of warping.

Gesso: The support. Wood. Oak, Poplar, Pear, Holly are my favourites. Costly. So, old abandoned furniture is a good source. Also get off-cuts from specialist timber merchants and look in skips. Roughly clean it up.
Sand it.

Size it: Rabbit skin glue: 1 part glue to 12 parts water; one thorough coat.

Gesso – Hard method: Whiting: readily available and inexpensive (builders' merchants.) Make up the size. 1 part glue to 9 parts water. This should be a stiff jelly when cold. Place the whiting in a metal bucket. Reheat the size, as hot as possible without boiling it. Add this to the whiting, stirring slowly with a wooden spoon until it is free from lumps and is the consistency of single cream. Rigorous stirring will aerate the mixture and cause problems when drying. Apply this evenly to the support with a flat brush. Allow to dry. Check the dry surface carefully to make sure there are no pinholes or cracks. These will remain always, no matter how many times it is recoated and must be avoided.

Repeat this at least 4 times with each coat of gesso slightly weaker than the previous one (this is almost a naturally occurring process as the size in the mixture will weaken upon reheating). I often apply many, many more coats. Don't worry too much about brush marks as these will be removed when sanding back the surface.

Sand it: I use wet and dry. Starting with 180 grade, ending with 1000 grade. Until the surface is perfectly white and as smooth and hard as glass. Excellent luminosity can be achieved by this method with less immediate absorbency of the paint.

Gesso – Soft method: Same as above but with a weaker size. 1 part size to 12 or less parts water. Diminished luminosity, very high absorbency of paint.

STORE AND CARE

• ONLY TRY THIS ON YOUR OWN WORK: If canvas warps or deforms from something poking it or resting on it, turn the painting around and brush some water into the back of the canvas around the indentation – brush it in like you

are priming it, but do not soak the canvas. The water will stretch the back of the canvas as it dries and remove most/all of the deformity. Don't do this on old paintings as the moisture can cause the paint to come away from the surface.

- Canvas can slacken after painting or over time. Artists' stretchers have special slots so that you can hammer wedges into them which slightly push the stretcher bars apart and re-stretch the canvas. Knock these in equally to avoid the stretcher going out of shape.
- To *unwarp* wooden stretchers, slightly moisten the wood and then clamp the stretcher tightly against something straight. Leave it a couple of days to dry out. Wooden stretchers will warp if exposed to damp, heat or direct sunlight.
- Place paintings on chops (two identical bits of wood or, ideally, hard foam) – never directly on the floor. Make sure the paintings are leaning straight against the wall to avoid the stretcher warping.
- If storing paintings together, make sure their stretcher frames can only rest on other frames and never on the canvas.
- If storing in your studio, paintings are best left unwrapped, in indirect light.
- If you have to take the painting off the stretcher and roll it – roll it face side out.

3D GENERAL

- When viewed in a glass vitrine, skilfully modelled, then sprayed using automotive cellulose paints, Blu-Tack is almost indistinguishable from bronze.
- If you need to have something fabricated, but the quote is above your budget, ask the fabricators if you can do some of the work yourself in order to lower the price. For example, if you need something sprayed and lacquered, much of the labour/

3D GENERAL

price is due to preparation sanding. This is something anyone can do easily, but takes time. Most fabricators are willing to strike a deal/compromise.

- Expanding foam sticks to a wet surface better than a dry – it even works as glue!
- When casting in Jesmonite, mix 2-3 parts powder to 1 part water.
 - ¬ Unlike cement, Jesmonite is not able to dry on sloped surfaces.
 - ¬ Jesmonite can be layered easily by applying fibreglass matting between coats.
 - ¬ Apply with a paintbrush to get an even surface.
 - ¬ Jesmonite can be used to resemble any texture.

PLASTER

- Plaster is quick and easy to use and relatively light.
- It is usually set in a mould or modelled while still wet.
- Mix casting plaster into water – never the other way around.
- As plaster sets it gets hot – don't cast body parts with it!
- Once dry, plaster is soft and brittle so it is best to build your work around a support system or armature.
- Dip lengths of scrim/hessian/jute into wet plaster and then drape around armatures/objects – this creates extra strength in the plaster.

> *Don't feel confined to materials or ideas. Sometimes it's ok just "making" or "doing".*
> **Helen Frosi – Soundfjord**

METAL

ROLLED STOCK

Refers to standardised lengths of profiles (end shapes) or plate metal (sheets). The metal has been rolled in certain ways to form these. This gives it extra strength and compression – removing imperfections.

Common available profiles: round, square, tube, box, rectangular, hexagonal, angle, unequal angle.

CAST METAL

Two-part casting: generally for simpler patterns, but a good knowledge of casting can allow very complicated shapes. The pattern is packed into sand, then split, and the pattern is removed and cast. To allow the pattern to come out, it requires relief angles or tapers on the surfaces (that are perpendicular to the split surface).

Lost wax: a mould is made out of a silicone, and then wax is poured into the mould. Bronze is poured through melting wax. You can have more intricate shapes, and don't have to worry about undercuts and tapers. More expensive.

MACHINING

All metal sections can be cut, so machining generally refers to processes beyond: drilling; milling; turning; pressing; rolling; folding.

PLASTER / METAL

WELDING

3 common types:

Arc (refers to its powerful electric arc): suited to larger stock – 2.5mm upward – of all steels. Not suitable for brass, aluminium and lower melting point metals. The most aggressive form of welding. Has good penetration (pushes into the stock). Generally the machines are more portable. Is limited by its aggression. There is a knack to the use of it, but once mastered will provide basic welding applications.

MIG (Metal Inert gas): best balance – covers all common steel profiles. Can be used on larger aluminium sections. Has a good range from small to larger sections. If the welder is set up right then the welding will easily yield results. Does require a gas bottle and so is less portable.

TIG (Tungsten Inert Gas): finer work – can do slighter sections of aluminium if ACDC. Not beneficial on larger stock or big productions. Requires gas bottle so less portable. Takes time to master the process.

BRAZING

A further metal-joining process using an oxyacetylene torch and a filler rod. Principles are similar to soldering, but temperatures and melting points are much higher. Not as strong as welding: acts more like a glue which bridges the surfaces, rather than fusing them together; uses a torch rather than a current. Brazing allows much more control and produces a cleaner finish. It also allows you to join different types of metals to each other and can even be used with non-metals (metalized ceramic).

FINISHING

General rule of thumb: the stronger and tougher the metal, the more work needed. Think carefully about trying to retain the finish of a rolled stock or cast object as polishing processes can be very labour-intensive and may not be worth the investment.

Otherwise perhaps...

Chrome plating	if you want a shiny metallic surface
Powder coating	will give anything a good even coating
Spraying	a finer finish than powder, for retaining more detail or if your object is already finished well
Galvanising	industrial look, zinc plating, normally hot-dipped so creates a dripping or flecking – not a uniform finish
Patination	essentially chemically accelerated oxidation (weathering/corrosion); colour and surface depends on metal and alloys; protects the surface layer from further corrosion

METAL TYPES AND GENERAL BENEFITS

Aluminium

Lightweight. Doesn't have the strength of steels and brasses. Good for a slick look.

Can get good detail.

Rolled Stock: is available in the widest variety of profiles beyond the common, because it extrudes so easily. Has more malleability as rolled than cast and will bend like steel. Good corrosion resistance – can easily be scratched – ends and threads easily broken, easily dented on edges.

Casting: Easy to cast. Cast aluminium is brittle so can shear on fine parts. Not suitable for regularly used threads or detail that will have a constant interactive use.

Good to machine (good surface finish – rapid material removal).

Welding: ACDC TIG only on slighter sections – heavier sections can be done with a TIG welder – however, consider other options of fixing (mechanical – bolting, riveting, etc.) as aluminium welding is more specialised.

Mid-range for cost.

Doesn't really tarnish, just dulls.

Brasses and bronzes

Often called Yellow Metals. Brass is an alloy of copper and zinc; bronze is an alloy of copper and tin. Due to various combinations, they can be seen as alloys on a sliding scale – some brasses are referred to as bronzes and some bronzes are brasses. Averages 10% heavier than steel! If you need it lighter, you get aluminium alloys.

Excellent for detail.

Rolled Stock: common profiles available.

Casting: easy to cast. Bronze expands ever so slightly in the mould before setting which picks up fine detail.

Good surface finishes – easy and quick to machine whilst having a good strength.

Welding: with the right set-up you can MIG and TIG; otherwise must be brazed.

Generally more expensive than other metals. Bronzes are much stronger and deteriorate less, but are the most expensive.

Certain amount of protection against corrosion – the metal will tarnish – mostly depending on copper content, it will go green.

Cast iron

If a steel has more than 2% carbon, it is considered a cast iron.

It is the step between the elements and our newer metals. Has a feel of being from a past age – there's something nostalgic and raw about it. Filthy to work with.

Can get larger detail.

Rolled Stock: plate or block.

Casting: great dimensional stability. Generally good for large castings that can be used in machinery as well as large bodies of weight that can be precisely machined, cheaply cast and be threaded into, turned, milled. Granular in composition, like aluminium when cast, but with greater strength, so can shear over length and over load, but if dimensions are right, it will take a great load as well as having a great compressive resistance (makes great machinery, bedways). Not for fine bits.

Unlike steels and bronzes, it doesn't have significant surface tension and thus does not bend or deform when machined.

Welding: modern cast iron can be welded. Older parts will need brazing.

Used to be the cheapest to cast. However, energy prices are whittling this saving down.

Generally resists rusting in normal indoor conditions. Will tarnish slightly – goes browny.

Steel
Black Carbon

Generally has a mottled finish akin to cast iron, although some is rolled to have a flat finish with a slight sheen.

Rolled Stock: common profiles available.

Not for casting.

Poor to machine but can be regularly drilled. Will hold a thread.

Welding: easy to weld – can use all processes, depending on job. Welding will deform (bend) the stock slightly – if you level off the heat on opposing sides, you can rectify this.

The actual material dimensions can vary from the stated/nominal stock dimensions which, as well as normally being bent out of shape, can make precise work unattainable. Best suited for basic structures that are welded together and can be negotiated in situ.

Cheapest, most readily used stock.

Will tarnish (rusty brown) on cut or ground edges if left raw.

Steel
Engineering stock
Stronger than black carbon steel. Has a lovely, slightly pitted, dull shine.

EN3 (commonly referred to as mild steel) is the most commonly used grade, although there are long lists of grades available.

Rolled stock: solid, heavier sections available.

Casting: can be cast.

Better to machine than black carbon steel, but time-consuming to do on larger amounts. Machining only one side of stock will release the surface tension and it will distort along that plane; this can be solved by machining the opposing side. This is not a problem in turning as there is only one distorting surface. Great strength. Drills well. Threads well.

Welding: easy to weld, can use all processes, depending on job.

Strengths will be sufficient for most applications, although you can post-harden components if you are going industrial on it.

Slightly more expensive, but definitely worth it for more precise work.
It does tarnish – goes browny, and will rust under poor conditions.

Steel

Stainless

Rolled Stocks: common profiles available. Better for components that can be easily machined from stocks available – making it cost effective in material and labour.

Casting: can be cast.

Two commonly used types

304: commercial grade. Good corrosion resistance. Tougher to machine than steel but easier than 316. Generally slightly cheaper than 316. Good surface finishes. Strength is akin to engineering steel.

316: food and marine grade. Excellent corrosion resistance. Expensive. Sexy. Good surface finishes. Good to machine – good to turn, but time consuming. Can easily distort due to surface tension. Great for lasting shine.

Welding: easy to weld, can use all processes, depending on job.

Most expensive stock. Good to consider whether it's better to use another metal and post-coat.

Won't tarnish under most conditions. Clean with a soft cloth, soap and water, or with a bleach-free glass cleaner. In more extreme cases use solvent. Always wipe the surface dry to prevent the formation of water stains.

FOUNDRIES

- Many people don't realise that steel can be cast – so can stainless steel – you just need to go to a larger foundry.
- Although foundries may get a small job done within a week, lead times can be very long (months) so worth thinking about timing.
- All should do bronze, lead, aluminium. The larger foundries do iron and steel.
- Generally you have three choices: for something complicated and/or very detailed, go to an art-specific foundry; if very simply made, it is worth trying the semi-specialist (mid-range) casters; if producing large numbers, or if you want to work with steel, it's good to try a big foundry.

Art-specific: go up to exotic alloys. More expensive but you are paying for expertise and the ability to do small runs. These foundries will do several different parts of the process for you and help you through the thinking. They are used to odd requests. More in tune with fragile work, specialist finishes, including patination, and the importance of detail.

Mid-range: go up to (possibly) cast iron. Like something straight out of the late industrial revolution. They will do small runs and batch productions of simple things – trade or industrial products, but they also do one-offs and are approachable for different work.

Large category – industrial casting: go up to steel. The least expensive, but you have to have your pattern totally sorted or at least your drawing fully CAD-ready. There is little leeway with these guys unless you are using their design facilities, but this will eat into the savings you are making. Designers can design patterns and do post-machining – otherwise they want the part and the number of orders.

MOULD-MAKING

There are many ways to make a mould and the best way to approach it is to assess certain requirements of your project before you begin:

How fragile is the master (original artwork) and can you afford to lose/damage it in the moulding process?

It is difficult to completely preserve an original artwork when taking a mould if the original is very delicate or made from wet clay or plasticine materials.

Does the object have many undercuts and overhangs?

Some objects are more complex to mould than others. If you have a spherical shape or a simple pattern you may only need a one or two part block mould.

More complicated objects may need a skin mould with a multiple-part jacket or 'mother' mould.

What will the final casting be made from?

Different moulding materials work better with different casting materials. For example: an alginate mould tends to work better with plaster casting; different silicones accept different resins.

How many castings/editions do you require?

Your moulding material will dictate how many castings you can extract. Alginate moulds will only make 1 or 2 casts; a good silicone mould can produce hundreds.

MOULD-MAKING

Popular Mould Making Materials

Alginate	Quick curing time
	Excellent for life casting
	Best used with plaster casting
	Deteriorates very quickly (24hrs if not kept moist)
Plaster	Good for inexpensive mother moulds or jackets when used with scrim
	Non-flexible, may require several parts to mould even simple shapes
	Requires good release and sealing agents when not using ceramic slip casting
Silicone	Versatile, and very flexible for both block moulds and skin moulds
	Comes in various shoe hardness
	Can accept a variety of casting materials
	Completely non stick
	Can make multiple casts
Fibreglass	Often used for moulding large simple shapes
	Very strong and light weight
	Can be used many times
	Requires release agent
	Fairly inexpensive

NON-METAL CASTING

Always check your casting material is compatible with your mould. If it is not, a
sealant or release agent may be required.

Popular Casting Materials

Plaster	Quick and simple process Inexpensive Compatible with most mould materials
Ceramic slips	Used in plaster moulds Requires firing
Clear casting resins	Used in plaster moulds Requires firing
Polyester resins	Versatile and can take various stone and metal fillers Can be used with fibreglass mat to make strong lightweight casts Can crack during curing in large sections

Polyurethane Resins	Can get very fast curing versions Can be used with fillers Can react with certain moulds
Epoxy Resins	Very high strength Can cure in shallow sections Can be used to varnish paintings and drawings
Polyurethane foams	Very lightweight Expand many times to fill moulds React with certain moulds and moisture
Acrylic casting plasters	Similar properties to plaster, but much stronger Can be used with fibreglass matting Non-toxic
Bio resins	Environmentally sound Similar curing properties to PU resins Can react with some moulds Non-toxic

CERAMICS

There are various approaches: hand building, slip-casting, press moulding, throwing, modelling, slab building...

Then there are the firing options: electric, gas, wood, raku, smoke...

It's worth getting professional advice in the beginning of a project. Many suppliers will advise you on how to use the materials you enquire about, but not necessarily advise on the correct route. An hour or so of tuition is worth every minute.

Different clays have different firing temperatues - these are high enough to vitrify the body – otherwise it will be porous. For functional use this is essential, but for sculpture it is not as important, depending on what effect you want.

EXPERIENCE IS INVALUABLE

- Make fragile objects on a sheet of paper on the kiln shelf to avoid breakages when loading the kiln.
- You need to have an idea of the finish you want and work backwards to choose your clay accordingly.
- Clay Suppliers – most suppliers have a technical advisor you can ask for help.

Stoneware
Fired at a high temperature to vitrify:1200º-1300ºC
Colour: varies from light grey to dark red, you can get a white
Strong, non-porous body
Can be unglazed or glazed

CERAMICS

Earthenware

Fired at a low temperature to vitrify: up to 1150ºC
Colour: varies from creamy-white to red-brown
Not as strong
Can be unglazed or glazed

Porcelain

Porcelain is the toughest, most unforgiving clay – often resulting in cracks and weaknesses – be sure to investigate semi porcelains, grogged and porcelain paper-clays if you are determined to use it.

Hard-paste: also known as true porcelain.	Fired at a high temperature to vitrify: up to 1350ºC Glassy look Hard, strong and non-porous For delicate objects with thin walls and some translucence Made from china clay (kaolin)
Soft-paste	Softer body than hard-paste Slightly porous The glaze is fired at a lower temperature than the body and looks like a separate layer

Bone China	A British soft-paste porcelain.
	Contains a high proportion of bone ash.
	Very fine and white.

General Building

- Dry clay slowly to avoid cracking – wrap it in plastic or erect a plastic tent over a large or complicated object to control moisture.
- Do not have closed pockets of air and try to make sure walls are no more than 2cm thick anywhere. If you need them thicker – dry them extra slowly.
- Dry objects thoroughly before firing.

Plaster for ceramics

Plaster is used to make moulds for casting clay: you can use wet clay (slip casting) and pour it into the mould making a shell of clay (a bit like making an Easter egg), or you can use plastic clay (out of the bag) to press it into plaster moulds.

The good thing about plaster is it is absorbent so it sucks moisture out of the clay quite quickly and you can remove it from the mould.

It is worth playing around with this process, but you can also go to professional mould makers when you get a bit more ambitious.

Plaster: for beginners, instead of buying the best plasters such as Keramicast or Crystacal, the same result is achieved by using Fine Casting Plaster.

Keep your plaster away from your clay – bits of plaster in clay will cause problems when firing!

Glazes

Glazes fire at different temperatures so you need to pick your glaze for your clay. Learning about glazes could last more than a lifetime – it is all about chemical reactions: between the raw materials within the glazes themselves, between the glazes and the clay you use, and what happens to the glazes at different temperatures. It is best to take an experimental approach to glazing until you have been doing this for many years, or unless you go to a professional. It is very unlikely the glaze is going to come out how you have imagined it in your head, especially at high temperatures. At lower temperatures (earthenware), outcomes of glazes are pretty reliable, and commercial glazes can be bought to achieve specific colours and effects.

Using pre-mixed glazes – found in most decent ceramics suppliers' catalogues – could be a good alternative to mixing up found or adapted glaze recipes.

Try testing glazes before applying them to the finished pieces – pop a glaze test in every kiln load.

Technical literature: *Ceramics Handbooks Series* **(A&C Black)**
The Potter's Dictionary of Materials and Techniques by Frank and Janet Hamer
(A&C Black)

Look at Lucio Fontana's ceramic works – not seen as often as his holes, but they are really beautiful.

K.T.C

PERFORMANCE

It is helpful to think of a few things when making performance work:

- When will the performance take place? Often performances are best NOT presented on an opening night. Private Views always have more of a party atmosphere and the work may feel closer to entertainment. Obviously this is fine if you want that for the work, or it is part of the work, but make sure it's for the right reasons. Don't let anyone pressure you into staging it when it doesn't feel right.

- Will the performance exist in any form after the live event? Will it be documented? Will this be a future life of the performance or a work in its own right? Film/stills? How many editions will there be?

- Can the performance itself be editioned?

- Can the performance be repeated without you? By instruction?

- Does it have or include: live or recorded music, a score, other AV components? If someone has the right to stage it, they should have access to these.

- Can the performance be sold? Many artists don't like to think in this way, but selling work makes you more independent of commissioning bodies and often more in control of your work. It makes you less reliant on fees for your performance – something the art world is only gradually getting around to understanding.

- Often with performance you have to pay performers – speak to the institution/curator in advance about this – if they understand, they should be able to help.

- As performance is a relatively new medium, try to be patient with those who don't fully get it yet, but always insist on what a work needs – only you can know this about your work.

PERFORMANCE

PAPER-BASED GENERAL

- Hot Pressed paper has a really smooth surface for fine and detailed work.
- For a rougher surface with a bit of a tooth, use Cold Pressed paper.
- Papers made from linen and cotton are the strongest. Paper made from wood pulp has more acid in it and becomes brown and brittle if exposed to light.
- Drawing: hairspray makes an excellent and affordable fixative. It will colour with age (we're talking decades here, but good to know).

PRINTMAKING

- Monoprinting is a great place to start – you really just paint on a smooth(ish) surface and then press down the paper onto what you have painted.
- There are many studios which offer courses on printing and then a membership to take time to experiment – these are a great way to see what is possible.
- If you have bad spatial awareness, use a mirror to get the back-to-front feel of printing – especially useful for lettering. Think of your tool as an eraser, not a pen.
- Make sure you have a clean, dry, flat place to put the finished prints before starting.
- Pine and Poplar are good soft woods to use for woodcuts – avoid knots and look for an even grain. For beginners, try Birch ply. Cut into the wood at a bit of an angle – never straight down and remember that every little scratch will probably show up. Don't forget sandpaper in your toolbox.
- If printing colour, print the lightest colour first.
- You can use ferric chloride instead of nitric acid. It is less toxic. It is sometimes sold by electronic specialists.
- Good website: www.nontoxicprint.com

- Remember to remove jewellery before beginning.
- Think about your edition number and stick to it. Smaller editions are more valuable. It is common for artists to keep two APs (artist's proofs) for themselves.
- For a very crude homemade press, I have seen someone use thick sheets of laminated marine ply and a car jack.
- Get copper sheets cheaply through metal suppliers, not printmaking suppliers.
- If you don't have access to large trays you can roll your paper and soak it in water in a drum/bucket.

PHOTOGRAPHY

Regardless what camera you choose, it is the photographer that makes the picture.

- If you are using a zoom, zoom in all the way to focus and then go back to the framing you want.
- Before buying an expensive lens, hire one and try it out.
- Try to choose prime lenses over zoom lenses – better quality.
- Lens caps, filters and shades protect your lenses. Invest in these – they cost a tenth of the price of a lens.
- When using flashes and extra lights, it's good to remember that the larger the light source, the softer the light will be; narrow, directional light is hard and distinct – good for texture and making forms really sharp.
- To get a softer light from a flash, stick some white card behind the flash head and point your flash up around 70 degrees so that it bounces off the card. If you need even more light, set up a larger card or get someone to hold it for you.

- If you want the opposite effect and want more of a spotlight, you can make what they call a snoot – basically a funnel/tunnel for the light. Wrap aluminium foil around the flash head and adjust the size and direction of the opening to highlight the spot you want.
- If you are going to America or know anyone who is, shop here: www.bhphotovideo. com It is my favourite photography shop in the world!

SLR (SINGLE-LENS REFLEX)

Non-digital = analog. This process actually captures light, and light is the best information you can record about light. Remember the pinhole!

- Film needs to be developed.
- Black and white chemicals are cheaper and easier to find, and the film is cheaper.
- Remember that there are two types of black and white film – one you can't develop on your own, but have to get done professionally. It has to do with the sensitivity of the film to red light – ask for the right one.
- When taking the film out of the camera in a dark room, remember to do it slowly – don't rush when wrapping in the canister, otherwise it jumps inside and you have to pull it out and start again.
- Doing the developing yourself is actually quite easy, but keep a diary because times of developing and exposing change the image greatly. If you ever want to repeat the effect or want to change the results, you need to know these variables.

DSLR (DIGITAL SINGLE-LENS REFLEX)

Digital – this is a digital representation of light.

- Digital is becoming better and getting closer to SLR quality. Can also do video.

- The great thing about digital is you can control so much of the process.
- Photoshop is the new darkroom – you can do everything you did there and more.
- Full frame – most professional, almost reaches quality of SLR.
- When choosing a camera, the two most important things are: number of pixels and size of sensor. Bigger sensors = more sensitive to light = less noise.
- It is tempting with LED screens to hold the camera away from you, but the closer it is to your face and body the more stable the shot will be.
- Buy a good IPS monitor to edit your photos. Calibrate your monitor every 2 to 3 months. A good monitor helps you see true colour and good detail.
- HDR (High Dynamic Range) – the HD of photography, but it isn't really as easy as in video – basically you have to take several pics and then process them together. The point of it is that it allows the camera to see more contrast – upping the f stops of a DSLR to the same number as the human eye: your eye has a dynamic range equivalent to around 14 f-stops; the average DSLR has a dynamic range equivalent to around 8 f-stops.

DIGITAL PRINTING DIY

If printing yourself, you don't need a mega expensive printer, but do use the best quality paper and archival inks you can afford. Also make sure you use the best printer settings for what you are trying to achieve. Remember that prints change slightly as they dry so wait around half an hour before you adjust your settings.

- Dirt and oil from your hands affect the colour being absorbed into the paper, so only touch the edges.
- The best archival papers are acid-free, pH buffered, lignin-free, optical brightener-free.

- GSM is the paper weight, it stands for grams per square metre.
- To figure out which side of the paper is coated (hard to tell with matte) dampen your fingertip and touch it to the corner – the coated side will stick a little bit.

Paper qualities to think about
 Colour
 DMax (the paper's deepest black)
 Colour gamut/range
 Brightness (on a scale of 1-100+)
 GSM/weight
 Caliper/thickness (mm)
 Opacity
 Texture
 ¬ Glossy: more contrast and detail
 ¬ Matte: unreflective, smooth and velvety
 ¬ Satin: soft shine
 ¬ Pearl: smooth – like a pearl
 ¬ Lustre: quite glossy, but a slight tooth breaks up the shine

STORE AND CARE

- How you mount and/or frame paper is vital to its preservation: the best mount board is 100% cotton Museum Board. Conservation Board is fine if made from chemically treated wood pulp.
- Paper in a frame should have movement space in front and behind it. Never press the paper right up to the glass – remember glass is a liquid.

- Direct light, moisture and acid are the main enemies of paper.
- If storing paper works unframed, store them with a layer of acid-free tissue or glassine between each sheet. A plan chest keeps delicate paper works safe.

SOUND
The term 'sound art' is about as irrelevant as the term 'visual art'.

- When starting to work with sound, don't be too daunted by all the information and all the technology. First-hand experience is always best, so speak to people, and don't forget the internet. Experiment and learn.
- Don't be tempted to buy your way out of a creative hole with more equipment: sometimes you can create your best work with the limitations of what you have (I created my first sound works using a cheap digital dictaphone, a £15 condenser mic and free mixing software).
- That said, good studio monitors for mixing are a must! Mixing in headphones is not only bad for your ears, but also for your mix.
- Download a recording app for your phone to get the best possible sound from it.
- If working with computers, remember there are some good free/cheap digital audio workstations out there so you don't need to spend a fortune to start.
- If you can't find the answer to a recording problem, use YouTube! Thankfully there are plenty of geeky boys and girls out there who love nothing more than explaining how to use software.
- Try final mixes on a variety of speakers (preferably some low quality too) to get a good picture of what it will sound like to most people.
- Be careful with your ears – once your hearing is damaged, it won't recover.

SOUND

- Remember volume does not always equal power. You can hear subtleties in quieter work that will be lost at higher volumes.
- Read *In Search of Concrete Music* by Pierre Schaeffer. An entertaining, heartwarming and enlightening read from the grandfather of Musique Concrète.

Recording in the field

Essential kit (for everyday use)

In a waterproof bag (then you are prepared for all weather eventualities):

☐ A portable recorder (with built in mics is fine)

☐ Other portable technical equipment you love (tape recorder, Dictaphone, etc.)

☐ Recorder wind shield

☐ Tripod (mini tripods are useful for lodging your recorder in nooks and crannies)

☐ Spare batteries (these machines always use more energy than you expect)

☐ Contact mics

☐ Camera (or camera phone) and charger

☐ Notebook and loose paper (lined and plain)

☐ Various pens and pencils

☐ Tape and string

☐ Scissors or army knife

☐ Mini screwdriver kit

☐ Water and food – don't give up on your explorations because of a rumbling stomach (which will also affect your recordings!)

When recording in the field in a populated place, try to be discreet (binaural or lavalier microphones can be good for this) and, most of all, respectful. Recording in public can arouse the suspicions of the general public and thus ruin your recordings. (Being approached by a policeman whilst recording a great set of church bells can be very annoying!).

- Also be aware of ethics – recording private conversations can be problematic! You may hear things you'd rather not hear...
- Visit la Casa del Suono (The House of Sound), in Parma, Italy.

ANALOG AND DIGITAL

Put 10 sound specialists in a room and they will argue for hours about which is best.

The main distinction:

Analog sound is how we hear sound. Analog recording records the full information about every sound wave – reproducing the variations sound makes in air onto a recording medium.

Digital sound records a digital representation of an analog signal. Using Pulse-code Modulation (PCM), it takes a sample of where the wave is at, a number of times each second (the sample rate) and records this as data. The unit of the sampling rate is Hz. So a 16,000 Hz recording has taken 16,000 samples of the sound each second. It then plays this back to us and our ears do not detect the missing bits. The higher the sampling rate, the better the quality, the larger the file size.

- This does not necessarily mean analog produces better listening sound than digital. There are too many other factors involved, but it does record more information about the sound.

- People choose to keep masters on tape because this has all the information you can get about a sound. You can make several digital variations from this analog recording.
- Digital sound can be compressed for storage and playback variations: data compression (codecs – lossy and lossless) and dynamic range compression.
- If sound quality is a major factor in the work, and the quality of your recording is good, try not to compress the audio. WAV files are most commonly associated with uncompressed audio.
- Detail and quality is always reduced with compression, but you need to determine if this matters, based on the specs of your recording device and the specs of the set-up for which you are delivering the sound. Always think about what you will be playing your sound on: speakers, drivers, amps, cable, will limit/boost quality.
- When making digital versions, like with video, there is no point in delivering a file at a higher quality than your recording device was able to capture – this is just going to increase your file size. For example: if you record with a device capable of recording at 8,000Hz there, is no point in later encoding with 11,025 Hz.

If you amplify shit, it's just louder shit.

Old sound engineer saying

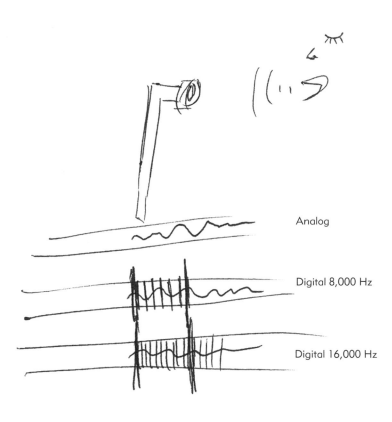

Analog

Digital 8,000 Hz

Digital 16,000 Hz

FUN FACTS

- The speed of sound (in air) is approx. 340 metres per second.
- Sound travels in waves. It has to travel in a medium (like air). It is the result of a vibrating object (vocal cords/guitar string/drum) causing the particles of the surrounding medium (air) to vibrate. How frequently the particles vibrate as the wave passes through the medium is called the frequency. We hear frequency as pitch. High frequency = high pitch = 'tight' wave. We measure this frequency, by the second, in Hertz (Hz). 1 Hz = 1 vibration/second.
- We measure other things in Hz. Don't let it confuse you: it is just a unit of frequency.
- Babies can 'hear' frequencies between 20Hz and 20,000 Hz. As we get older, we cannot perceive the higher frequencies above around 16,000 Hz. Cats hear up to around 64,000Hz; dolphins can hear up to around 150,000 Hz; elephants hear as low as 16 Hz and their calls go as low as 5Hz – we suspect that they 'listen' to the vibrations through the earth with their feet.
- Some low frequency vibrations cause nausea. Cool.
- The threshold of hearing this is the faintest sound we can hear. It is the sound of particles of air moving one billionth of a centimetre.

Hope is for the hopeless just like work is for the useless.

Shahin Afrassiabi

FILM & VIDEO
- Analog and digital.
- Aspect ratio = width in relation to height (w:h)
- For film the aspect ratio is usually expressed with the height as unity: 1.37:1
- For digital it is a simple ratio with whole numbers: 4:3 or 16:9 (widescreen)

FILM
The analog version.
Shooting on film is expensive, considering digital is more or less free now. However this is perhaps to its advantage in that you will consider everything before you press the record button – you learn skills and techniques quickly and in depth.

This is the moving image version of analog. You are recording light as it enters the camera rather than a digital representation thereof. Film actually records far better quality information than HD. However, the speed at which you can capture and play back the information, and the quality of playback, is limited by the capability of the recording medium and equipment.

These are the basics: you choose a stock and shoot your film. You take it to a lab to be developed. They give you a rush print. You edit this – literally by cutting it up and taping bits together. Now called a cutting copy, you take this back to the lab/ to a neg-cutter who will cement splice your negative, guided by your cutting copy, into an A&B roll – this is then taken to the printer to make a print.

GAUGE: is the width of the film. The most common are: Super 8, 16mm, 35mm, 65mm. A lot of artists use 16mm, so we have concentrated on that here.

FILM & VIDEO

16mm can be shot as Standard 16 or Super 16 depending on the camera used.

Standard 16mm
Picture area: 10.26mm x 7.49mm.
Aspect ratio: 1.37:1 (very close to 4:3, TV)
Double-perf: perforations on both sides – usually for high speed cameras.
Single-perf: perforations on one side and soundtrack strip (magnetic strip for analog recording) on the other.

Super 16mm
Picture area: 7.41mm x 12.52mm
Aspect ratio: 1.67:1 (very close to 16:9, widescreen, HDTV)
Wider because it takes up the space used for the soundtrack, so you have to use single-perf film. If you want to project it as film with sound then it needs to be enlarged to 35mm, or the sound has to be played on another device.

You can shoot film in widescreen or extra widescreen using an Anamorphic or 'squeeze' lens. There are several different types of lens which give you different widescreen formats. It literally squeezes the image during capture. A similar lens is needed on the projector to expand or un-squeeze the image during projection. Super 16mm can extend to extra widescreen (CinemaScope) – up to 2.35:1

Film gives you a physical sense of duration: measurements of film = time.
Oliver Bancroft

Film Stock

Companies that produce film stock: Kodak; Orwo; Agfa

Fuji closed the film department at the end of 2012, but you can still get stock here: www.filmstockclearance.com

List of questions to consider when choosing stock:
- Do you want to develop the film yourself?
- Black and White or colour?
- What are the light conditions you will be filming with?

New film stock will last longer if you freeze it straight away – thaw in a plastic bag so that condensation forms on the bag not the film.

Negative and Reversal

Negative film is just like a photo negative and is all in reverse so it has to be printed on another film stock for projecting. It is available in a wider range of speeds and colour balances, and has wide exposure latitude.

Reversal film records a positive image directly on the film. It is usually associated with very bright and strong colours so you need to decide if you want this look. It is less expensive, has a higher contrast than negative, and preserves better. However it has a very narrow exposure latitude. Making film prints from a reversal film is a little more complicated than doing so with negative film.

EI: (Exposure Index). This is basically the speed of the film and you choose the film depending on what light you are shooting in. You choose this by ASA/ISO numbers. The higher the number, the more sensitive the film is to light, but also the more grainy the film image.

COLOUR: colour balance in stock has two main categories: daylight (D) and tungsten (T) – which represent what type of light you are shooting with.

Ektachrome 7240 stock is really grainy and good for getting that nostalgic look, but remember you will lose detail. Graininess is always more obvious in shadowy or underexposed areas.
Kodachrome colour film is reliable even when long out of date.

Developing
• Most labs only develop and digitise (Telecine/TK).
• You can develop your own films – just like still photography. Make sure to choose the right film stock – it's mostly a question of chemicals available.

Printing
• Some labs will develop your negative and give you a print.
• You can ask the printer to print the image in a certain way to give a certain look
– e.g. sepia, changing colour ratios, contrast, colour balances.
• You can have your film printed on acetate or polyester based film stock:
You can tell the difference really easily: you can tear acetate film.

Acetate is brittle, heats up quickly and damages and tears easily. It is alright if you are doing a screening, but most often artists' films are in more or less constant use in the gallery setting. Acetate film can be alright if you have a very long looper thus giving the film time to cool down, but you will need to use a specific projector for it. Never use plastic leader with acetate film as it shrinks at a different rate.

Polyester is more expensive, but is much better for use by artists. Polyester is stronger and tougher and so wears better than acetate. Its storage life is up to ten times longer because it is far more chemically stable.

Editing on film

- The great joy of using film is to edit the film itself with a blade and tape!
- The numbers down the side of the film are called Key Numbers and are really useful for finding frames. 16mm has a key number every 20 frames (most common) or 40 frames in some film stock. If you want to edit as film with a cutting copy, be sure to ask for the key numbers to be printed.
- For complicated/longer films, a Steenbeck Editing Table will prove essential. You get courses and workshops to learn to use them. One of the great things about them is that sound and image are kept separate so you can synchronise them. To edit film with sound on a Steenbeck, you will need your sound on SEP Magstock.

Further reading: Cherry Kinoe *Wondermental...*
http://en.pleintekst.nl/cherry_kino.pdf

Splicing

This is cutting the film and then joining it together to make loops or edits.

Tape

- The quickest way to splice film together and also the easiest to remedy. Unless you are making a simple loop, tape splicing is really for editing your cutting copy.
- Each film gauge has its own size splicer. CIR splicers are a good solid make. Be sure that the blades are sharp, push the guillotine arm toward the film and cut quickly for best results.
- Many splicers will have a metal knob on the side – this very gently moves the teeth, pushing the film together/apart for a perfect join.
- Don't be afraid to stick the tape down properly to the film. It needs good contact.
- The splice must be taped on both sides of the film. After doing both sides it is always worth turning the film over one more time and cutting the tape – this makes sure the edges are smooth and sprocket holes cut cleanly.

Cement

This is for neg stock, not film stock (you cannot splice polyester film this way); the process is complicated and normally used for cutting and editing your negative – it's the most affordable and most durable, but you need someone to teach you.

Cameras

- Because basic film formats have remained the same, you can still use old cameras – they just need to be working properly.

- When considering what camera to use – if you are having sync sound then you want a camera with a crystal sync motor.
- For a sync camera, Arriflex, Ecclair and Aaton are reliable makes.
- A Bolex camera is a great non-sync 16mm camera. It can do stop frame animation as well as a variety of film speeds and it is wind-up – no batteries needed.

See: Andrew Alden http://bolex.co.uk/andrew/Bolex_Site/BolexHome.html

DIGITAL/VIDEO
- Carry spare batteries and memory cards!

Memory cards
- SDSC (Secure Digital Standard Capacity): up to 2GB
- SDHC (SD High Capacity): between 4GB and 32GB.
- SDXC (SD Extreme Capacity): between 32GB and 2TB
- CF (Compact Flash): more professional use, 2TB and above; different speeds:CF, CF High Speed, CF 3.0, CF 4.0.

Choosing a camera
- Go online and read the reviews!
- Think about your end result – the one you want most often, and work backward.
- Camcorders are designed for continuous shooting. DSLRs are not.
- Camcorders look 'video'; DSLRs look 'film'.
- DSLRs are inferior for recording sound, but there are ways around this.
- **Zoom:** if you want to zoom lots, go for camcorder.

- **Resolution:** are you going full HD? You want 1080p.
- It's worth remembering, if choosing your camera for video and looking at megapixels – what are you going to play your video on? The highest resolution players we currently have are 1080p = 2.1 megapixels. 4K is coming but that's still only around 8.5 megapixels. There is no point in investing in mega megapixels over other features when, for now, the quality is just going to be lost on playing.
- When choosing a camera, make sure it has a separate audio input – most should have a mic jack. The pricier ones have more professional XLR inputs.
- **HDSLR**: is a DSLR camera with the capability for HD recording.

Filming
- Keep a checklist of equipment throughout a shoot.
- For panning shots, pull your tripod handle gently with a rubber band – elastic absorbs movement making it look smoother.
- Experiment and see what is possible.
- www.vimeo.com/videoschool

Sound
- DSLRs record sound, but it's not great, so plug in a mic and/or use a portable audio recorder.
- DSLRs don't have XLR inputs, but you can use XLR adaptors.
- Double-check power requirements: XLR microphones normally power off the camera; microphones for a mini jack usually need batteries – have spares.
- Make sure your microphone is on and the camera set for it. Older cameras won't detect an external mic automatically. You have to go into settings and select.

- Do a sound test before you start recording and listen to the playback.
- If you go for a wireless mic, make sure its receiver fits into your audio input.
- Professionals tend to use portable audio recording devices for the best sound quality – go with the kind of sound you want: digital recorder, dictaphones, DAT, minidisk, tape, your phone. Experiment with sound, but read online reviews about devices before you buy. To sync sound when editing: clap your hands or tap something loudly on camera for a sync mark.

Editing

- Remember that all computers have free editing programs built in: Mac: iMovie; Windows: Windows Live Movie Maker. These are actually pretty sophisticated; you don't have to invest in the more expensive programs until there is something you need that one of these can't do.

Most programs run along the same lines. It all just takes some time to get used to the frills. The 4 step guide:

1. Put your files in the Bin (it's really called this).
2. Arrange them in time (on the timeline) – you can trim them down and move them around while doing this.
3. Get your audio onto the timeline – look for a special button (something like sound and music), trim and arrange as above.
4. Export

Ok yes, it's a lot more complicated, but when you have mastered the basics there are tutorials on your software, helpful videos, and a million experts on the net.

• You cannot upgrade quality in editing: eg. if your camera records at a certain resolution, you can select to make it higher, but your file still only has the information the camera recorded – you will not be increasing your quality, just increasing your file size.

Compression & coding/decompression & decoding

Compressing and decompressing, and the ways to do it, is seriously technical stuff, but we have tried to include the basics that you will need to think about for making and showing video.

The less encoding you do, the bigger your files will be. There will be more detail in the video and audio files, but remember that the quality/detail has to be there in the first place.

Don't over-spec the containers and codecs for lower quality recordings: eg. if your camera records 24 frames per second, there is no point in encoding it at 60.

Match your specs with your recording device and save a few versions at different formats and qualities. Make your master the highest res possible for what your camera/audio recorder can achieve, and then export different formats depending on where they are being shown: cinema, DVD, Blu-ray, various media players, online. Be prepared to compromise depending on your media player (that you have now/will have in the future).

Resolution

Resolution is basically how many pixels an image contains.

It is typically expressed as: image width (in pixels) x height (also in pixels).

You usually want to match the resolution of your camera.

Common (current) resolutions:

 SD (standard definition): 640 x 480

 HD (high definition): 1280 x 720

 Full HD: 1920 x 1080

As a shortcut, sometimes people just refer to the height (480/720/1080)

Get ready – Ultra HD is coming: 4K: 3840 x 2160 pixels or 4096 x 2160 pixels.

4K is four times the high definition resolution of 1080p.

For resolution to be displayed it also involves scanning:

 'p' : progressive

 'i' : interlaced

Progressive scan is twice as fast as interlaced.

The difference between 720p and 1080i is minimal.

1080p – is the topmost quality we can do at the moment.

Frame rate

Video is usually produced and shown at between 24 and 60 frames per second – 'the frame rate' – written as fps.

You usually want to match the frame rate of your camera.

You can export with a variable frame rate, but this can cause problems; play it safe, stick with a constant frame rate.

Shorthand: 1080p/60 = "resolution of 1920 x 1080; progressive scan; 60 frames per second."

Bitrate

Bitrate is the amount of data that is used for each second of video, generally measured in kilobits per second (kbps).

If the bitrate is too high, your file will just be too big without any real increase in quality. If too low, you lose detail and start to see those hazy blocks.

Some media players specify the maximum bitrate they can play.

CBR (constant bitrate): uses the same amount of data every second.

VBR (variable bitrate): adjusts the amount of data used depending on changes between frames.

Quality between CBR and VBR varies, to begin with just try your video in each and see which is better.

Video Formats

Video formats involve codecs and containers, although people also call containers formats or file formats.

For the purposes of thinking about it for delivering your film, think of a codec as *co*mpressing/*co*ding and *dec*ompressing/*dec*oding the video and audio files you have edited. It compresses them up into smaller bundles and puts them into a 'container' so you can carry them around and store them easily. When you want to show your film, it takes them out of the container and decompresses them so they look nice.

Codecs

There are two main types of codec you will need to think about:

Intra-frame codecs – use these for editing – record and store all of the information about every single frame – examples: Uncompressed (but very big file sizes); ProRes; DV; M-JPEG; X264 lossless

Inter-frame codecs – use these for delivery – from frame to frame, sometimes very little changes (for example a background may change very little in each split of the second, or just one part of the frame will be in motion), so the computer just records the changes instead of all the information about the still. To determine the amount of change, a computer uses a codec – examples: XviD, DivX, 3iVX; MPEG-2; MPEG-4 / H.264; WMV; RealVideo; VP6, VP7, VP8

• You have three main things to choose: a video codec; an audio codec; and a container to put these two into. The three have to match each other, and they have to match the media player you will be using at the other end.

Decent audio codecs:	Good video codecs:
AAC	H.264 (also called MPEG-4 part 10 or AVC)
MP3	MPEG-2

• For video: H.264 is currently the most widely supported, the most versatile and you can adjust the size depending on what you are doing with your video. H.264 also gives you a higher bitrate for your file size.
• For Blu-ray you can also use H.264.

- For Audio: AAC is currently the most supported.
- If you need a particular codec, download it from the internet – always best to go to the manufacturer's website. Remember codecs have to match your operating system.
- If you have sound but no image, it is often a codec problem.
- Get ready – High Efficiency Video Coding (HEVC) is coming. It should double the compression ratio of H.264 while providing the same or better quality, and it will support Ultra High Definition.

Containers

These 'contain' the files for you once the codecs are finished with them.

Most good containers can hold a variety of codecs.

Container formats related to Mac and Windows:

Quicktime (MOV) – Mac

AVI – Windows

Other containers: MP4, FLV, ASF, MKV, VOB, OGG

Containers are identified by filename extensions, i.e. the .xxx after the name of your file. For example:

Extension Filename	Container Format
.mov	Quicktime
.avi	AVI
.mp4	MPEG-4
.mkv	Matroska
.rm/.rmvb	RealMedia

- MP4 containers are the most widely supported.
- H.264 and AAC in MP4 will give you good quality, decent file size, and play on almost anything.
- MPEG is slightly annoying because there are containers and codecs named this (but they are different things).
- Best not to use H.264 with AVI containers.
- If playing off a laptop, I always use VLC – it has the most codecs on board and can be used on Mac or Windows.
- I struggle most with codecs when playing off a media player . You really have to check the individual media player to see what formats and codecs it will support (these also might be limited in resolution and fps). Check all these, then deliver your file accordingly.
- For Brightsign media players (got to love them!) deliver your file like this: Quicktime .mov container; H.264; AAC; at 25,000 bitrate. If you use the MPEG transport stream as the container, you can take this up to 35,000 bitrate (.ts)

Various calculations online: www.hdslr-cinema.com/tools

Freeware: Video Spec – this is great, you can analyse any video. Use Bitrate Pro as a calculator for bitrate variables: http://videospec.free.fr/english/

Good luck!

SHOWING

ART MOVING

Large digital files: www.yousendit.com; www.wetransfer.com

WRAPPING

~Obviously there is a range of possibilities when packing work – if your work is going around the corner and being unwrapped straight away, you can use pretty much anything. If it is being shipped to different countries, it needs pretty good protection. If it is being stored, you have to use archival materials. If it is very delicate, you need proper protection….

~Oil paint prefers to remain unwrapped, as will many sculptural materials, because they are organic and need to 'breathe' – but they have to be protected. Try to balance the needs of the work and the needs of the shipper.

~Always try to use archival (non-acidic) materials, in particular when they are in direct contact with the surface of your work. They are more expensive, but they will not harm your work. For long term storage, this is essential.

~Try to keep and recycle materials.

~Use profiled foam for corners and edges – often called blue foam. Pipe lagging is available from all hardware shops and makes an inexpensive padding for corners and delicate edges of slim, hard works/framed works (after wrapping). If you cannot afford either of these, make your own with bubble wrap, cardboard and tape.

~Works framed with glass: place strips of tape across the front of the glass, from top to bottom and from side to side, at intervals of a couple of inches. Using good quality masking tape will avoid marking the glass. If the glass breaks, the tape will stop the glass from moving and damaging the work.

Materials

Glassine/Acid-free tissue: comes in rolls or sheets – the tissue is softer than glassine, but glassine often comes in wider rolls – use shiny side in. It is light so you save on weight costs. Try to always make this your first layer when wrapping. If you do, it will protect the surface of the work and you can then use cheaper solutions for the following layers. Place layers of this between individual works on paper.

Polythene Sheeting: great for most works to protect them from moisture and damp. It is rot-proof and resistant to most chemicals.

Polythene Foam Rolls: (Sometimes called Ethafoam – can be recycled.) Like the sheeting, but with more cushioning – excellent for packing, but slightly more expensive. It does not degrade, so this can be put against surfaces.

Bubble wrap: never put bubble wrap directly into contact with your work – it degrades and marks the work. Always layer the work with acid-free tissue first. If transporting over short distances and you have nothing else, fold the bubble wrap – bubbles in so that they don't touch the work.

Cardboard Sheeting: is great but has a high acid content – so make sure you have a layer of tissue protecting the surface of the work. You can get archival paper board, but this is more expensive.

Loosefill: the polystyrene chips/popcorn – great for putting around sculptures. Wrap items first to avoid direct contact with surfaces.

ART MOVING

Foamcore: is a layer of foam sandwiched between two layers of board. It comes in various thicknesses. Use the archival variety if you are using it as a first layer.

Stratocell: a polythene foam, but you can get it in thick sheets – great for lining crates. It is very light and is non-abrasive – can be re-used several times and then recycled. It also comes in pink! (for anti-static).

Crates: obviously the best option for safety - cover with several coats of polyurethane to make them water-repellent. Remember to make the crate bigger than the work so you have room for cushioning – around 5cm on each side.

 ¬ Use plywood for crates, not MDF – it takes the shock of impact better.
 ¬ For paintings in crates – screw mirror plates onto the back of the painting, and then screw into the inside back of the crate. The painting cannot move around and you do not have to use any packing materials. For oils this is particularly good so that the oil can breathe.
 ¬ With a permanent marker draw a circle around the screws that you need to take out to open the crate – this helps whoever is going to open it at the other end.

~ If you cannot afford a crate, wrap paintings in acid-free tissue (they must be completely dry – remember glazes can take a considerable time to dry properly), then wrap paintings in polythene sheeting. If the surface is sticky and you have to wrap it, just use polythene.
~ Always include a condition report of your work in the packing. Ask whoever receives this to check the work against it.

HANDLING

~ You can use professionals, but they are more expensive and, frankly, many of them do not care about the work at all.

~ You can learn the basics of art handling, but it seems you can never learn a feeling for art and an understanding of its value. Without this you cannot be an art handler.

~ If you can afford to, it is always worth insuring your work – to the maximum value of the retail price.

~ Whenever possible, have two people to handle work – especially getting into vehicles.

~ Take your time, discuss with the team in advance how you will be moving something, which way you are moving or turning, what the general plan is.

~ Do not take your hands off the work without ensuring the other people know you are doing this – tell the team out loud and ensure the work is supported by others before you release it.

~ The person who walks backward when carrying a work of art is 'doing the Momart Shuffle'.

~ Carry paintings by their edges, on the stretcher frame. Even when wrapped, the stretched surface of the canvas is very delicate.

~ Don't leave work unattended. This seems obvious, but a large sculpture by quite a famous artist was 'lost' recently by an art moving company – it was over 2m³!

~ Whoever you use to handle/transport your work, remember that they are working for you and have to go at your pace. Don't get flustered and start rushing. For each item, give clear, firm instructions about where to hold it, how to place it in the van, etc. Generally, if transporters see you know what you want, they will comply with the mood and pace.

TRANSPORT

~ Who pays for transport will really depend on the space. Often artist-run/ independent spaces rely on artists to help with these kinds of costs.

~ For gallery exhibitions it is standard practice for you to pay the cost of transportation to the show, and for them to pay the return cost. It is always worth making sure in discussions that this is the case.

~ Museums will usually pay the costs both ways.

~ There are many good art movers out there, but it is always worth working with them/overseeing what is happening, as some will always be better than others.

~ The large moving companies have a range of transport options, but for smaller art movers you need to choose according to what vehicle they have. Think about size, but also weight – will you need a tail lift to get works onto the truck?

~ The man-with-a-van movers usually charge by the hour, but will often give you a special day rate if you have lots of deliveries to make.

~ Always label your work – your name and address, the title of the work, any references the receiver has requested. Put as much information on the packing as possible: a broken stem glass = fragile; an umbrella = needs to remain dry; an upward arrow = which way is upright.

~ If transporting to Europe and/or to the main fairs: Isler & Isler will do part load transport – basically you share the truck and it saves costs: www.isler-isler.ch – look under 'Collective Shipments' for dates.

ART TRANSPORT DIY

You can of course hire a van and do your transport yourself. This may not work out cheaper unless you have a number of deliveries to make or are going quite far. The costs add up quite quickly: the cost of hiring the van, taking that extra premium on insurance, the time it takes to pack the van and drive, asking a friend to help you, paying congestion charges and fuel.

~ For local deliveries, with some works you can just jump in a taxi – often the most cost-efficient.

~ If you are transporting the work yourself, you may feel less packing is necessary, as you will be in control of its safety. Never hurry while transporting work; a few minutes saved by hurrying will cost you if you have to repair work or framing.

~ When loading your van or car, stack works on their edges rather than flat and on top of each other. If a work slips, it can so easily apply pressure to work underneath, potentially breaking the glass or damaging the work.

~ When loading many canvases one beside the other, always make sure you rest stretcher frame against frame. If size makes this impossible, use strips of 2"x1" timber to separate one work from another. Rest the strips of timber in a position which is against the wood of both the works it separates, and tie the timber down firmly so that it won't move during transit.

~ If your paintings are too large for your vehicle, you can remove them from the stretchers and roll them up. Always roll paintings around a tube with the maximum circumference possible. Don't roll them too tightly, and roll with the painting on the outside. This should help prevent the paint from cracking. Cover the whole thing with polythene. You can re-stretch the work in the gallery.

~ Strap works to the side of the van when transporting. Art moving vans will have several bars to do this, but you can make a plan in most vans. Ideally use cotton straps – don't use string as it will dig into the works; ratchet straps are ok, but their edges are quite rough so only use if the work is properly wrapped. Place blankets between works, or between the straps and the works where necessary.

~ Place some kind of padding between each work. Blankets are the best, but you can use anything which will absorb vibration.

~ Tie and wedge everything so that nothing can move during transit.

~ Drive slowly and carefully.

FRAMING
Either for looks or for conservation.

STYLES
Box frames: An internal gap, keeping the work away from the glass, is created by inserting a "fillet" (spacer) along the inside of the moulding. Box frames can also be used as regular frames without fillets. The mount/work will then be sandwiched to the glass. Although no gap is visible within the frame, its depth is visible from the outside.

Standard frames: These do not have enough space to insert a fillet. Glass, mount and work are sandwiched to fit. These regular mouldings offer a wide selection of shapes and profiles. Ornate frames can come pre-finished or in bare wood to be finished by the framer. They tend to be chunkier and come in a variety of profile shapes inspired by various stylistic eras (Dutch Old Masters, Victorian, etc).

Canvas tray frames: Often referred to as gutter boxes, these L-shaped mouldings are designed to accommodate stretched canvases or paintings on board. They cannot be glazed as they do not have a "lip" which traditionally holds the glass in place; they do not cover the edges of the painting so none of the artwork will be "lost" in the framing.

FINISHES

~ Pre-finished wooden mouldings come in a variety of shades – painted, stained or gold / silver leafed. They can be an economical option.

~ Bare wood moulding can have finishes custom-applied in order to exactly match the requirements of the work.

~ Bare hardwood mouldings made of grained timber such as oak, ash, beech or maple can also be clear-waxed to achieve a natural look.

~ Stains are waxed to ensure a long-lasting finish.

~ Painted finishes can be sealed with a clear matt varnish for extra protection.

~ Metal frames come in a variety of profiles with shiny, frosted or brushed finishes. They are a good solution when a thin frame is needed. Their construction and sturdiness allows them to support heavier glass than thinner wooden frames.

Don't be an arsehole.
Ron Henoq

FRAMING

MOUNTS

Standard mount card	is made from acid-free woodpulp and comes in a wide variety of colours. It delays increase in acidity of work and offers good protection from environmental toxins, but it is unsuitable for museum standard framing.
Conservation mount card	has been chemically treated to remove any dangerous elements from the source material (woodpulp). The mount protects work from contamination over very long periods of time. Conservation mount card comes in a limited range of colours.
Museum mount card	is made from cotton rather than woodpulp, which requires the least amount of processing in the manufacturing process. It is the highest standard mount card available. Museum mount card comes in a limited range of whites and off-whites.

The window mount: is the most traditional way of mounting work. An aperture is cut out of the mount card to reveal the work.

A float mount: also called a "lay-on". The work is simply laid atop the mount card and held in place using acid-free adhesives. The work can either be fixed on all corners (good for transport) or just suspended from the top, allowing the material to move over time and with atmospheric changes.

A raised float mount: a smaller board, usually acid-free foamcore, is placed in-between the work and the mount card, lifting the work off the backing and creating a shadow and the illusion of floating.

~ Works can also be framed "straight in" without any kind of mount card surround. They will then be backed by a sheet of mount card which acts as a barrier to toxic materials.
~ Specialised dry-mounting to aluminium, Foamex or card must be carried out by a specialist.

GLASS
Regular float glass: a reflective glass. It comes in thicknesses of 2mm, or 3mm for extra large pieces.

UV glass: comes in a variety of grades and can offer up to 99% protection from damaging sunlight. It has been coated with a UV filter layer. It is also reflective and looks almost identical to regular float glass. A minimal reddish hue can only be seen in direct comparison.

Non-reflective glass: often called diffused glass, has been etched on one or both sides. It cannot be used in box frames as visibility and clarity decreases instantly when the glass is raised off the work.

Anti-reflective glass: often referred to as museum glass, is of a very high standard and usually offers a degree of UV protection alongside highly reduced reflection. It is the best reflection-free option.

Acrylic glass: also known as Plexiglas, is a great solution for framing large pieces when size and weight push the boundaries of safe frame construction. It is much lighter in weight than glass and will not break. However, by its nature it holds a static electric charge, attracting dust, making it harder to keep clean. It also scratches easily.

THE SPACE

Raise high the roof beam, carpenters.

Sappho

BUILDING

Walls

~When building a showing wall, it is advisable to create a shadow gap at the bottom of the wall: it helps with painting, and evens out the appearance of the floor surface. It only needs to be up to 18mm from the floor.

~ To make your shadow gap, place offcuts of wood of the required height on the floor at the joins, and rest the plasterboard/MDF on these to fix.

~ Use tapered-edge plasterboard so that you can tape and join seams.

~ For plasterboard or plastered walls, a plaster filler is always the way to go to cover seams. It is much easier to do than you are led to believe, especially over smaller areas. Mix it like casting plaster, use it before it goes off, and have your end finish in mind. Don't be intimidated. We are artists – we can do this stuff. Two coats of plaster, with sanding in between, should do the trick.

~ Polyfilla is great for smaller holes or cracks -- using the white stuff will always be quicker for over-painting.

~ When building MDF walls, it is preferable to have a chamfer on both meeting edges, creating a triangle to be filled. You need to do the first fill with a two-part filler, then sand it back. Minor blemishes can be resolved with Polyfilla.

~ Decorators Caulk is a cost-effective wall filler which can be painted over almost immediately (unlike other fillers which need time to dry). This means last minute rehangs are possible. However it is not sandable so you have to do a very neat job.

~ Non-professional: seams in walls can be covered with tape, but you are always going to see it. The best is watercolour tape, which you wet first, as this is designed to resist wrinkling on drying.

Painting

~ If the wall is newly built and you are painting onto MDF or plasterboard, mix about 20% water into your paint. The surface absorbs the water readily so it makes a good first coating, preventing freckling on drying.

THE SPACE

~ When painting a wall, use newspaper or cardboard to cover the floor – the paint dries quicker than on something like plastic. Check your feet before you step off the protective covering.

~ If you spill paint/tread it into the floor, clean it up immediately.

~ Put your tub of paint and equipment onto something with wheels so that you can roll it along with you and don't have to keep moving to get it. A pallet/heavy board on a pallet truck is nice and wide for all your paint, rollers and trays.

~ Always use a paintbrush (approx 30mm wide) first, to prepare the edges and awkward corners, then roll over the top. Roll all paint out evenly.

~ Buy a Purdy's roller and brush and you can keep it for years, IF you clean it properly. If you buy a cheap, nasty roller, it will only be good for one or two sessions, so why even bother?

~ A good quality extension pole will help to give purchase whilst doing a large area. Even if you can reach without it, the job will be better and quicker in the end.

~ Generally stick to an up-down motion when rolling and only go horizontal for awkward bits. Make sure to blend in wet paint strips from the edge of the roller.

~ Be methodical. Start at one end and get into a pattern. This may seem boring but the reason will become clear when you come to the second coat and you don't know where you have been and where you haven't!

~ Roller paint takes a while to dry to its final colour. It will look patchy at first but give it an hour or so and it will clear. Patience.

~ Leyland SDM do a very good quality, and not too dear, Brilliant White Vinyl Matt. If you go back to them often, they'll give you a good discount even if you don't have an account – just be friendly!

~ Use a finger to extract those little bits of dry paint or roller-weave from the surface being painted before it dries. You can have a quick clean up roll to remove finger marks and the end result is leagues ahead.

~ You can keep a roller (or brush) wet for a while (during lunch-break) by wrapping with a plastic shopping bag; this is only good for a few hours – don't get lazy and store it like that overnight!

~ Always clean your roller and brushes thoroughly at the end of the day or when finished. You will save so much money in the long-run by looking after painting equipment (and tools for that matter). It takes a while to clean a roller properly, patience. Hold brushes, bristles-up, beneath the tap to clean the fat bits.

Snagging

Screw holes

~ Remove any screws carefully. Unscrew slowly, taking into account any curvature in the screws – often people will hammer screws up or down to achieve a level – this bends the screws and makes them harder to get out.

~ First sand down the area where the screw has been until flush with the rest of the wall. Never be tempted to miss out this step – you will see the need for it later.

~ Get a filling plaster – white quick-drying Polyfilla is usually the easiest.

~ Mix it up properly – should be a bit like toothpaste – not runny, not hard, no lumps (or as few as possible).

~ If under-prepared and missing the correct metal tool (filling/palette knife), a credit card/unused rewards card works for filling the holes. Some people insist it is easiest to do it with your fingers. Whatever works for you.

~Always fill a little proud (bulging out from the wall a bit). As the plaster dries, it shrinks. You want it to shrink back just enough to fill the hole.

~For deeper holes it is worth filling twice. The first will fill most of the hole, the second will go a little proud.

~It doesn't matter if it looks a bit fatter than the wall, but it is always worth smoothing out the edges of the plaster – you will find a lot of (later) sanding time is taken up smoothing the edges. Eyes will notice a line far easier than they will a bulge.

~Let the filler dry COMPLETELY: trying to sand it before it is properly dry will cause a mess.

~If you have made a travesty, use coarse sandpaper first, but as you get better you will really just need a very fine sandpaper (or a worn-out coarse one) for this job.

~What you are trying to eradicate is any difference in light as it hits the wall; a fine sandpaper makes fewer grooves to catch the light – hence better.

Re-painting

~Always snag with the same paint as has been used for the wall! This is vital! And when I say the same paint, I mean the same brand, the same super-matt/matt, the same white/brilliant white.

~When snagging a wall don't brush the paint on in a traditional way – use the bristles end of a dry(ish) brush, perpendicular to the wall, with just a little paint. Dab at the wall until all the paint is dotted evenly over the surface – this copies the marks that a roller leaves. An old and rather damaged brush works best for this.

~Once you have done the snagging – once or twice depending on the whiteness of your filler – you will still notice the wall has an uneven appearance, especially when viewed from the side. This is caused by different paint timings and sanding dust on the wall.

¬ If you are on a very tight budget: wipe the wall with a clean, very slightly damp cloth – over the whole wall – using circular motions – think Karate Kid.

¬ If on a slightly bigger budget: water down white paint – you can get away with 1 part paint to 2 parts water – and roller the wall.

¬ If money and technicians are no object: go at it and roller another full layer of paint onto the wall.

~If you have marks coming through the paint from previous use, or if the wall has been painted another colour: an oil-based coat before your emulsion helps with marks; a basecoat before emulsion gets things white quicker.

~To dry a wall in the last few minutes before the opening – we have all been there – use a hair dryer.

INSTALLING

PREPARATION

A week or so before you hang your work, go and have another look at the space. Note the following:

≈What kind of walls and floor it has

≈How the present show, if any, is hung

≈ How many sockets there are and their position. Do you need extension cables?

≈ How much power do you require from each extension? If you are plugging a lot of things in, it is always worth counting up what power you will be using before you start blowing fuses:

¬ amps = watts/voltage

¬ Any piece of electrical equipment will have the watts (W) on a label somewhere – find this

¬ In the UK the nominal supply voltage is 230V (volts)

¬ Divide your watts by 230 to get the amps

¬ Add up all the amps you will be using

¬ As the name suggests, a 13 amp extension cable should not have a load of more than 13 amps connected to it. Doing so will blow the fuse.

≈ What the lighting is like: is it adequate? Is it adjustable? Any particular problems?

≈ Note the dimensions of the walls and any doorways and staircases

Find out when you can deliver your work, when you can have access, and if there are any restrictions on the hours you can work in the space. Will you hold keys or will someone else have to open and close it?

Check on the nearest hardware and stationery shops and have a look at what range of things they stock in case you need anything during install.

Mark your tools so you can identify your own!

Checklist (short):

- ☐ Tape Measure
- ☐ Hammer
- ☐ Pencil
- ☐ Drill-driver/screwdrivers
- ☐ Spirit level
- ☐ Screws and plugs
- ☐ Note paper

Checklist (long):

- ☐ Tape Measure
- ☐ Hammer
- ☐ Drill-driver/ screwdrivers
- ☐ Bradawl
- ☐ Electric drill (with percussion head for masonry)
- ☐ Drill bits for masonry & wood
- ☐ Staple gun & staples
- ☐ Spirit level
- ☐ Pliers
- ☐ Pencil
- ☐ Stanley knife
- ☐ Filing knife
- ☐ Extension lead
- ☐ Screws and plugs
- ☐ Masonry nails
- ☐ String
- ☐ Emulsion paint
- ☐ Polyfilla
- ☐ Sandpaper
- ☐ Vacuum cleaner
- ☐ Broom
- ☐ Dustpan and brush
- ☐ Stepladder
- ☐ Cleaning cloths
- ☐ Dusters
- ☐ Methylated spirits
- ☐ Cotton gloves for art handling
- ☐ Note paper

~ You will be surprised how much time you need to put a show together well. Take the time to get things right; a badly hung exhibition can make even the strongest work look less than its best.

~ Placing your work is best done on your own, or with one other whose judgement you trust. It is not a good idea to have more than three people putting together a show, unless it is a large event. If you have too many people installing, too much time can be taken up making decisions.

~ If you are doing a group show, this may have to be arranged differently. The group will need to discuss how each artist's work looks. Choose one or two people to organise the placing of the work, with everyone else agreeing to accept their decisions. You might find a different solution – it will depend on the situation – but try to come to an arrangement that is practical and which satisfies most of the people involved.

~ In a group show, often a certain work with particular requirements will start the placing process. As far as possible consider the needs of the work, and the needs of the show; this can often be in conflict with what the artists think they need.

~ If you are showing alone, don't forget to arrange for at least one friend to help you.

~ If you have the luxury of doing so, take along more work than you think you will need in the exhibition. This gives you extra choice when considering the balance and overall feel of the exhibition. You may well be surprised at how different your work looks when you get it into the space.

~ Even though there are no rules, what is important is that your show looks professional, and that the people who have curated/installed the work look like they actually care about how it is received. Try to get the lighting, hanging, projections straight and at the best possible quality that budgets will allow.

Speak to skilled professionals in multimedia, carpentry, framing, hanging, etc. to see what the best methods are (or ask someone who has a lot of experience such as an established gallerist or art tech). If you can, employ skilled tradespeople to do work for you, and try to learn from them: wall painters, plasterers, framers, hangers, archivists, lighting techs, good curators.

PLACING YOUR WORK

~ Try to approach placing your work with an open mind. Try to be receptive to how things look and be prepared to experiment.

~ Some spaces have very definite characteristics, dominant features or divisions that may help you to make decisions and suggest a starting point. The nature of the space in relation to your work may well dictate certain arrangements. Sometimes because of dimensions, a piece of work can only go in one place, for example, and you can then build the exhibition around this.

~ Take your time in deciding where to place each work. Move things around, trying different combinations until you feel quite happy with the position and look of each piece, and with the look of the whole show. Sometimes the two might seem incompatible, so try to achieve a good balance between the whole and the individual works.

~ The wall surface itself may affect the look of the work. For example, a highly textured wall surface/face-brick will detract from some works more than others. If the wall surface is different in different parts of the space, this may also affect where each work goes.

~ If your works are placed on the floor, ask yourself how its colour and surface affects them. Bear in mind that the gallery floor may not be flat or entirely horizontal, or that it may well be completely different from your studio floor.

~ Ask yourself if the works need to be seen in relation to one another, as a group, or as separately as possible.

~ Consider how each work looks from all viewpoints, and from close up and afar. Consider how all the works relate to any others within view at the same time from all viewpoints.

~ Remember that when placing works against the walls prior to hanging, they will often appear to take up more space than when they are hanging on the wall.

~ Get into the habit of noticing how other exhibitions are put together, and how you feel about the way they look; you can pick up many dos and don'ts like this.

~ If work is presented well, you should be able to concentrate on the art. That is what you want.

HANGING

Before you begin, have a table or special place to keep your equipment. This will save a lot of time spent searching for things during hanging. Return everything to this place when not in use.

Common fittings/systems

Straphangers: metal hanging fixings secured to either side of your frame, stretcher frame or base. They allow the work to hang parallel to the wall and distribute the weight of the work most evenly across the frame. Straphangers can be used with screws and wall plugs or with picture hooks.

Split battens: can be used for small and large/heavy works that require extra support. A batten, angled at the top, is screwed level into the wall. A corresponding angled batten is fitted to the back of the work; if framing, you can ask for this batten to be incorporated into your frame. The two fit together. The work floats a bit away from the surface – depending on how thick the battens are. For large works, you may need to put a second batten system toward the bottom of the work – this adds strength and stops the work leaning in toward the wall. You can get metal split batten systems which are very thin, for smaller works.

Canvases on stretchers: can be hung from the middle stretcher bar, or from the top of the stretcher on two screws in the wall. The advantage of this system is that you can adjust the work laterally just by pushing the work along.

Mirror plates: aren't used much anymore – the problem is you always see them. The good thing about them is they act as a cheaper security fixing.

Cord: not the best system but you may want it for an 'old-fashioned' look. Make sure it will hold the weight of the work. You can purchase cord intended for this purpose from frame makers, framing suppliers and some art supplies shops. This kind of cord, after being threaded through the rings can be twisted around itself. As strain is put on the cord, it tightens its grip.

If you use any other type of cord, for example, string, you will need to ensure that it will take the weight of the work and that the knot you make does not slip. In this case, use two or more separate strands of cord (the number depending on the weight of the work), so that if one should break, the others will still hold the work.

The knot you tie should be a reef knot. A granny knot will slip if any strain is put on it, whereas a reef knot tightens (see illustration).

Steel cable: more for hanging 3D work from the ceiling. Best to use stainless steel wire – use a cable with a load five times heavier than your work. There are various cable grips that can be used with them – always use more than one grip for safety, and always try to use a system that is adjustable.

Use a hand drill for fixing into work – electric drills just don't have as much control and cause too much vibration.

Set your height and mark the wall

~Generally, eye level is the place to hang the work (the centre of the work at around 150-165cm from the floor). But, don't feel you should rigidly stick to this rule. Allow the content of the work to dictate your presentation – just keep in mind that at around this measurement is the average comfortable eye level for viewing. You can mix it up with salon hangs or whatever you like for other aesthetic and conceptual reasons, as you please. There are no real rules.

~If choosing one centre height for several works, mark your height on a length of timber that you can stand upright on the floor to make measuring quicker.

~ Remember that your fixings will probably not be at the top of the work. Take this into account when making your drill marks.

~ Use a long spirit-level – this allows you to mark out distances of holes on the spirit-level itself before you get onto the wall. You can then mark several holes on the wall and get them level at the same time. If you don't have a long level, you can tape a shorter one to a straight edge.

Fixing

~ The screws you use for most hanging need not be any longer than three quarters of an inch. This size screw will hold quite a weight. Screws are very strong, and there is no need to give yourself extra work by using long screws. But do make sure that the drill bit you use, the wall plug, and the screw are the same numbered size, so that you have a good fit.

~ You may often find that the wall being used is of plasterboard construction. The wood or metal uprights which hold the plasterboard should be at vertical 60cm intervals. These will hold more weight; you may have to do some exploratory drilling to find them.

~ Sometimes you are bound to have to screw into the spaces between, which may just be plasterboard. There are special types of plugs available from hardware shops, which expand into the cavity to provide a rigid fixing. They are more expensive, but they do work. Ask for various plasterboard fixings.

~ If the wall is a partition wall and you have access to the other side, you can use butterfly screw fittings, also available from hardware shops. These are large bolts with a special bit which grips the wall behind. These will hold quite considerable weights.

~ Use shield-anchor bolts for fixing heavy things to masonry walls, ceilings or floors. Sizes: M6/M8/M10. Remember the size quoted is the size of the thread, not the whole bolt. Use a bit 6mm larger than the size.

~ Go onto the Rawl website to look at various fixings for inspiration: www.rawlplug.co.uk

~ Tap wall plugs in gently.

~ Before hanging from the ceiling, find out how it is made and how strong it is – you may need to fix a plate to the ceiling to help spread loads.

Adjustments

~ Having the work level may not necessarily make it look level if the walls, floor or ceiling are themselves out of true. Step back and rely upon your own eye to make a final decision.

~ One reason why works may not look straight when hung is because they are not square themselves. You can check whether this is the case by measuring the diagonals of the work; if the work is square, they will be equal. If the work is not square, you will have to compromise between what the spirit level dictates and your own measurements when hanging the work.

~ If the work is square, there are ways of correcting a light slant caused by the hanging:

¬ Remove the screw holding the lower side of the work and pack the bottom of its hole with a matchstick or something similar. Then replace the screw. This will also help if the screw won't tighten up, or if the hole is too large.

¬ One cause of a slant can be that one of the screws went in crooked. You can check to see if this is the case by slightly unscrewing the screw. If it is crooked, it will unscrew with a rolling action to the head. You can leave this screw only half way in, this will tend to correct the slant. Remember that the hole made by this screw will not be straight.

¬ You can also adjust screws by tapping with a hammer, one up and one down.

¬ You can wrap masking tape around the lower screw head to bolster up the height.

~ If canvases are warped, you can use Velcro at the back of the frame to stick them to the wall.

~ Don't be tempted to use Velcro or other sticky products unless you are hanging something very light. So much damage is caused to works by them falling off the walls. If you must, use lots of Velcro and staple it to the wall for extra strength.

~ Remember, sticky products will damage and mark paper – sewing pins, panel pins and magnets are good alternatives.

~ Strengthen corners of paper works with linen tape for hanging. You can also use linen tape for hanging paper works. Linen tape is removable.

Check your walls for dirty prints or pencil marks.
Snag them – keep them perfect.

PLINTHS: TWO VIEWS

Mitring the edges of a plinth will make a nice clean edge, but some find it difficult to get it looking good and will end up using a large amount of filler, which may crack out when the plinth is moved. I prefer to spend a bit more time on a butt jointed box and square off the edge with a block plane and sander. You can then go over the end-edge area with a PVA solution to 'prime' the MDF. If it's finished and painted well, no one will know (and it will make a stronger box).

Don't try to drill directly into MDF edge without pilot drilling first. You will get a cleaner edge if you hold both pieces together and drill the pilot the whole way through rather than doing the two holes separately.

An MDF butt joint has some adjustability once it has been screwed (with pilot hole). Screw it tight. If the joint does not sit together flush, take the screw out 10-15mm and wiggle the joint so that the two edges are flush; then whilst holding, screw back together. You can do this two or three times and still have quite a solid joint. There's probably about 1.5-2mm adjustability, depending on thicknesses etc.

Don't try to screw with anything less than 50mm to the end corner of a butt joint. It will split (whether you have done a pilot or not). If it splits, the joint is weak and looks rubbish.

Include a shadow gap around the base of your plinth to help give a clean look on any floor surface. The gap around the bottom is also very useful when it comes to moving the plinth around. It is helpful to make the gap no less than 15mm so that you can get your fingers under it for moving.

Alternatively, some do prefer to mitre rather than butt the edges, finding it very tricky to get butt joints to become invisible. The secret to success here is to make your plinth six-sided. This takes care of the inherent weakness you'd get in a five-sided mitred plinth.

The sequence is: measure and mark carefully; use a tracksaw to make the 45° cuts, four per board; drill half a dozen small but snug holes through the faces at 90° along every edge; insert a panel pin into every hole; glue and offer up the first two edges (for this you'll need to arrange a stack of books or whatever so that two edges can meet horizontally at right-angles and you can have access to them without needing five hands); steadily and lightly tap in the pins on one of the slabs; flip it over (carefully – at this stage it can easily collapse) and tap in those pins too; repeat the process till the four long sides are together; carefully get it upright on the floor and attach the lid; flip over and attach the base.

At this stage, the thing is quite sturdy and you can go around every side using a punch to drive the pin-heads below the level of the MDF surface. Now drag filler into any faults or gaps along all the edges, and also over all the pin-heads, and, once dry, it's ready to sand and paint.

A shadow-gap is easily achieved by gluing/screwing a board of a suitably smaller size onto the base.

FIG. 1 (see ILLUMINATING)

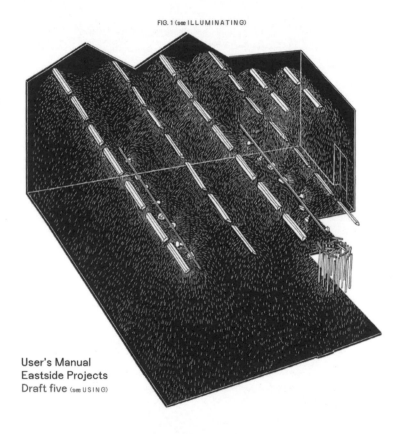

User's Manual
Eastside Projects
Draft five (see USING)

LIGHTING

~ Spots: normally bulbs with built-in reflectors that focus their beams on small concentrated areas.

~ Floods: fitted with powerful tungsten halogen strips, give an even spread of light over a wider area.

~ The colour of the light can vary according to the fixture and the bulb, which can be closer to either the orange or to the blue spectra of white. Corrections can be made with filters or different types of bulbs.

~ Both types of light are normally fitted into tracks. This allows them to be moved along the tracks. The fittings themselves also allow for the lights to be swivelled and moved up and down.

~ Lots of galleries use fluorescent strip lighting – hung or fitted in an unbroken line, this can look good and be a cheaper alternative to track lighting.

FILM

[also see Making section]

~ In a gallery setting it is always better to get your film printed onto polyester. This costs slightly more, but is much more durable than acetate and is better for looping.

~ It is always a good idea to have a spare print of your film on hand.

~ Get your projector from a projection expert and see if they have an advisory service that goes along with this. It is a beautiful medium, but it is work-intensive and you want people to help you who know what they are doing.

~ The lens you use and the distance of the projector from the screen, will determine your screen size (see table).

	Distance	1 metre	2	3	4	5	6	7	8	9	10	15	20
Lens													
12.5mm	H	0.58	1.16	1.72	2.32	2.88	3.4	4	4.56	5.14	5.76	8.64	11.5
	W	0.76	1.53	2.28	3.06	3.86	4.56	5.32	6.04	6.88	7.72	11.58	15.44
25mm	H	0.29	0.58	0.86	1.14	1.44	1.69	2	2.28	2.57	2.88	4.32	5.76
	W	0.38	0.77	1.14	1.51	1.93	2.27	2.66	3.02	3.44	3.86	5.79	7.72
38mm	H	0.19	0.38	0.56	0.76	0.94	1.13	1.32	1.5	1.69	1.86	2.84	3.79
	W	0.25	0.51	0.76	1.02	1.26	1.51	1.76	2.03	2.26	2.53	3.8	5.07
50mm	H	0.14	0.29	0.43	0.57	0.72	0.86	1	1.13	1.29	1.44	2.16	2.88
	W	0.19	0.38	0.57	0.77	0.96	1.13	1.32	1.51	1.72	1.93	2.89	3.86
63mm	H	0.11	0.22	0.33	0.44	0.55	0.66	0.77	0.88	0.99	1.1	1.66	2.21
	W	0.15	0.3	0.44	0.59	0.74	0.9	1.04	1.18	1.33	1.48	2.22	2.96
76mm	H	0.09	0.19	0.28	0.38	0.47	0.56	0.66	0.76	0.85	0.94	1.42	1.89
	W	0.12	0.25	0.38	0.51	0.63	0.76	0.89	1.02	1.14	1.26	1.9	2.53
89mm	H	0.08	0.17	0.25	0.33	0.41	0.5	0.58	0.66	0.75	0.83	1.25	1.67
	W	0.11	0.22	0.33	0.45	0.55	0.66	0.78	0.89	1.01	1.11	1.67	2.23
100mm	H	0.07	0.14	0.21	0.29	0.36	0.42	0.5	0.57	0.65	0.72	1.08	1.44
	W	0.10	0.19	0.28	0.38	0.48	0.56	0.66	0.76	0.88	0.96	1.44	1.93

~ Thought is divided on timers – these turn the projectors on and off to give them a break. Some experts say it is good, some say they cause more problems than they solve.

~ Have a can of air on hand – the biggest enemy of your film is dust, so spray the air around the projector before loading your film and give it a good spray out every now and then.

~ Hold canned air upright when spraying, otherwise the liquid at the bottom of the can might also spray out.

~ Cover the projector with a very light dust sheet each evening.

~ Ask the gallerist/invigilator to listen out for the film when it is on – most times you can hear when something is starting to go wrong.

VIDEO/DIGITAL

List of useful equipment:
- [] A continuity tester – to test if cables work
- [] Screwdrivers – varied heads & some nice small ones
- [] Long-nose pliers
- [] Cable cutter
- [] Spare fuses
- [] Lots of cable ties
- [] Blade/knife
- [] Torch
- [] Spare batteries
- [] Cable adaptors
- [] Electrical tape

Projectors

Things to think/know about:

Lumens: a measure of brightness. Everyone thinks brighter is better but often in a gallery setting you will be projecting in a very dark screening room, in which case you don't need them that high, so rather invest in other features. If there is ambient light, you need lumens.

Resolution: If you film in HD 1080, then you need this projector. Always get the highest spec you can as the technology is moving so fast.

Contrast ratio: How black is black? A very important consideration, particularly if you are working in HD black and white.

Aspect ratio: although technology is improving to make this less of a problem, if you are going to be showing a lot of widescreen, check that your projector is NOT native 4:3. If it is, they will sometimes show a 16:9 in the 4:3 space, with black lines top and bottom. This however makes for a lower resolution projection because you are only using part of the screen. If you shoot in HD, or most of your stuff is widescreen, it is always best to get a native widescreen projector.

Keystoning: DO invest in a projector which has some keystoning – one day you are going to want it. 3D keystoning is actually rather brilliant – try it. BUT keystoning makes you lose resolution and can distort the image, so this is no replacement for a proper set-up!

Lens shift: if you can afford it, get it – it will save you so much pain.

Inputs: HDMI does pretty much everything these days, but there is something comforting about having inputs for the good simple yellow, white and red.

Built-in Audio: don't bother, it's crap.

LCD or DLP: If you care about colour, it still has to be LCD. DLP is getting better and less noisy. They can be much brighter than LCDs.

Lamp life: particularly important for a gallery setting, as we use these projectors for much longer periods of time than most other users. Get the longest you can afford that fits with your other chosen specs.

Noise: how noisy are the fans? – This is important for us.

Flip: can you invert the image? For ceiling-mounting? For rear-projections?

~ Don't be afraid of the menu – you cannot break a projector by pushing menu buttons – and you can always restore to factory settings and try again – so get used to your projector and see what it can do!

~ Most manuals are now online – don't forget about them.

~ Buy a spare lamp when you buy your projector – it is always going to run out at the wrong time. Store the lamp carefully – it is very delicate.

~ Don't block fans/ventilation ports on the projector – it will overheat and turn off.

~ Don't ignore the message to clean your filter – this will cause it to overheat.

~ Never turn a projector off at the wall until it has cooled – press its off button and wait for the fan to stop running before turning off the power. You will ruin your projector very quickly if you don't wait for it to cool down by itself.

Screens

~ Distance from screen is important for size of screen, and you need to work this out by brand of projector.

~ This screen size calculator is so useful:

www.projectorpoint.co.uk/screensizecalculator/screensizecalculator.cfm

~ The mirror trick:

 ¬ If you have to project in a small room but want a large projection and don't have an *über* closeup expensive projector, you can bounce the light off mirrors. Each time it bounces it makes a bigger image.

 ¬ The biggest challenge is to mount the projector and the mirror/s so you can adjust them, because you want to get the alignment correct rather than relying on keystoning. Fiddle and try.

 ¬ Never zoom after setting up the mirrors. I don't understand the physics, but it's a world of pain.

 ¬ Remember that every time you bounce the image, you will lose brightness.

 ¬ If you want to project onto the floor, bounce it off a mirror so you can keep your projector horizontal – better for it.

floor

~ For rear-projecting you will need a proper screen fabric specifically designed for this. Rear projecting is your best bet if the room you are showing in is quite light as it allows a good, bright image on the screen, but you need the space behind the projector to be nice and dark. DIY rear-projection screen: buttermilk painted (with a roller) onto glass – great for shop windows.

~ You can buy a range of expensive screens, but often these are pointless for a gallery setting (unless rear-projecting). The special fabric is designed to give the best light to an audience sitting in front of it – like the cinema. In a gallery you are often moving around, seeing things from several angles, so you want a screen with an even surface. If you have a good wall, just paint out a screen in white with the rest of it black. If you want something raised off the wall, a board or canvas stretcher made to the right size and painted well, and evenly, works brilliantly.

~ You MUST use a matt emulsion paint for your screen – get into satins or glosses and you will have a light-reflecting nightmare of a time.

~ If your image is smaller than your screen or skewed or slightly off the edges, and you don't want to/can't use keystoning, make the image smaller than the screen and use black masking tape to make crisp edges (much easier than black paint!).

~ ALWAYS test the exact film you are going to be showing before doing the final adjustments to your screen size – each film is different, and although this might only be a few millimetres, you want the screen to be the exact size of the film. If you have used different sizes of images within your film, pause the film on the largest image (frame) and set up the projection and screen based on these measurements. If you are not setting up the projector yourself, it is always useful to give this information to whoever is.

~If you want a semi-opaque screen use shark's tooth gauze. Light behind it to see through the screen as well as the projection.

~Screenings: use a laptop. Have all films up and ready to be played in different windows. Test everything in advance. Check the laptop's Energy Saver settings and tick 'never' so it won't fall asleep. Set the projector's background screen to black so the audience does not have to stare at blue-backgrounded branding.

Aspect ratio

Easy maths: If you know you want your screen 3m (300cm) wide, how do you work out what height it needs to be so it will fit perfectly?

Ratio 16:9 Height = 300/16x9 (300 divided by 16 multiplied by 9) = 168.75

Ratio 4:3 Height = 300/4x3 (300 divided by 4 multiplied by 3) = 225

Not the most elegant maths, but useful on site. Essentially you are breaking things down to a base unit and then building up again in the desired ratio.

It works the other way as well:

The screen needs to be 2m (200cm) high, how wide will it be?

Ratio 16:9 Width = 200/9x16 = 355.55

Ceiling Mounts

The most popular set-up for a gallery, as the projector is out of the way.

~ You can either make a shelf high up on the facing wall, or mount your projector from the ceiling (upside down, so you will need to flip the image).

~ Data projectors were first designed for people who wanted to give presentations – we are essentially adapting them. Think of them as designed to sit on the middle of a desk and project straight, and up, (see illustration A). So if you hang them from the ceiling, think of them the opposite way – middle, straight and down: hang them upside down, in the middle of the screen, at the same height as the top of the screen. This way you won't need to keystone (see illustration B.)

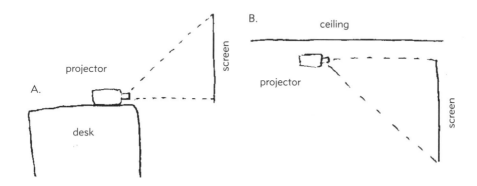

~If you don't have a ceiling mount: most projectors have threaded holes in the base – these are usually M3 or M4 thread – make sure to get the right bar. Turn the projector over and lay a piece of paper over the base. Mark an outline of the projector; mark which side is the front; stab out the holes with your pencil. Mark all of these onto a solid piece of MDF/hardboard. Drill holes in the board for the thread. Push the threaded bar through the board and screw into the projector holes – secure with nuts and washers. Now you can suspend the whole thing from the ceiling. (It is worth using this method even if the projector is to be placed in the normal way on a shelf, as it will therefore be more secure).

~When suspending away from the ceiling, use four lengths of threaded bar with nuts and bolts. This allows you to adjust the whole shelf up and down as necessary.

~If dropping a longer distance than a ceiling mount/thread allows, a single metal bar with fixing plate forms a great projection mount.

Monitors

When they talk about the screen being so many inches, this is the diagonal measure from one corner to the other.

~Latest flat screens are super-simple – HDMI cable – player of choice, and go.

~If worrying about the resolution of your file to play on these, remember that for monitors measuring below around 40 inches, the human eye cannot tell the difference between 720p and 1080p.

~We love the older monitors (video monitors) – those nice black boxes. It is worth picking these up (in decent working order) whenever you can as they are becoming rather rare.

~ Make sure they have decent inputs though – some older video wall monitors only have the old 9 pin input – they need a conversion box which costs a fortune.

~ Hantarex and Barco are the most beautiful. Sony cubes are nice too.

~ It is a myth that you can turn them off at the plug without damaging them – use the power button.

~ CRT (cathode ray tube): older technology, fragile and heavier, cannot be turned on their sides or on their backs.

~ LCD (Liquid Crystal Display): not as good if viewed from different angles (designed to be viewed from the front), although newer versions are getting better. Can be turned – don't have to remain landscape.

~ Plasma: can be much larger, but often not as bright – need darker conditions, but they're getting better.

Common Cables & Connectors

~ HDMI connector cable – use it whenever you can. Has video and audio streams in one cable. Does HD and everything downward.

~ RCA/Composite AV (some people call them phono cables – especially when using them for audio) – the red, yellow and white. Standard practice:

 yellow = video
 red = audio right
 white = audio left

However, the cables are identical – they are just coloured differently so you don't get confused about which jack goes in which socket.

~ RF connectors – usually for a domestic set-up only – they carry picture and sound.

~ BNC: good option and great over distance. They are similar to RF. They lock into place, so make for a better connection.

~ SCART cables can be a little unreliable, so have backups. Because they are heavy and bulky, they are not great over long distances or in tight/awkward set-ups. You can get converters for them.

~ VGA: for playing off a computer. Remember you will need a separate cable for audio: phono or mini jack.

~ S-Video: the cable separates colour and brightness signals. This gives a good picture.

Media Players/DVD/Laptop/Mac Mini/Blu-ray
[also see Making section]

~ You need to deliver your file in the right format, with the right codecs, to the limitations of the player you will be using. Find out what these are.

~ Everyone loves digital media players, and if you can afford a Brightsign, there is nothing better. It is pretty much designed for exactly what you want – continuous looping, no menus, no settings, just great, good quality playing.

~ WD is a decent, inexpensive make – weirdly the older ones were better – problems with the orange wheel taking too long to load in the current ones, but if you update the software/firmware and get the right format, it can fix the problem.

~ Cyclone does a pretty good small version with 1080p upscaling, but the blue power button is very bright in the dark.

~ Laptops are always good, but it's not often you have a spare lying around or can go very long without your personal one.

~Mac Mini's are great, but if you are just going to use them for projecting, the Brightsign is better. A computer is designed for all sorts of things – the Brightsign is just designed for this.

~I have found Blu-ray really reliable for good quality HD and other files. Often people don't realise that their files do not need to be as massive as they export them, so they think Blu-ray is too compressed – worth looking into this.

~DVD – the old faithful – still a great option if you export your file right, but obviously not much good for HD. Never put it on top of your projector – it will get too hot.

SOUND

~Think small and oddly shaped when thinking about sound. Vast symmetrical halls will give huge reverb (unless that's what you are after).

~Invest in rechargeable batteries. And a charger!

~Cable ties!!

~Electrical tape is brilliant in every way for myriad reasons: colour, size, flexibility…

~Blu-Tack makes excellent adhesive for keeping speakers in place on stands.

~Use Merino wool curtains to keep wanted sound in and unwanted sound out. (Velcro curtains to walls/ceilings to keep the most sound and light in/out).

~Try to avoid really cheap gaffer tape. You will end up with sticky cables afterwards. When pulling cables off the floor, pull the tape off the cable first – do not pull the cable up and try to remove tape afterwards. It will just wrap around the cable and make it sticky.

Performing

~ Make sure you have all the equipment you think you will need for a live performance (and more!) and most importantly, make sure it all works.

~ A four-way multi-plug will not take up a lot of room in your bag, but is invaluable.

~ Again, a small set of headphones need not take up a lot of room in your bag, but could prove invaluable, particularly in situations where you cannot get amplification before sound-check.

~ Take more leads than you think you will need and make sure they all work.

~ DO contact venues and galleries well ahead of time to find out what equipment is available to you, and ask if they have a technical specification of the space.

~ DO let the venue know in advance of any particular technical requirements to make sure that they can accommodate you.

~ Remember that sound technicians and engineers are there to work for the venue and therefore (for the duration of your performance) for you. Don't be afraid to tell engineers what you need and how you would like your work to sound. Do this during set-up, installation and sound-check, not just before your performance is due to start (unless you want to make the engineer very cross and possibly make you sound horrible!).

~ Don't pretend to be a diva! You aren't. If you're not happy with the sound, speak to the engineer politely and clearly – remember that engineers have the power to make you sound dreadful if they so wish.

~ DO ask about fees and expenses before agreeing to anything.

HEALTH & SAFETY

~ Be sensible. The last thing you want to do is hurt someone or yourself.

~ Never work at height alone.

~ When drilling/hammering into a wall, check first to see if the electric cables are surface mounted. If they are not, that means you don't know where they are. Get yourself a Voltage Detector. They are not expensive. If in doubt….. Don't.

~ NEVER drill directly above or below a socket or switch.

~ Get your electrical equipment PAT tested.

~ Check all cables to see if they have been cut or squashed.

~ Don't leave extension cords rolled up or bundled – they can get hot when current is running through them. Try to use an extension lead of the right length.

~ What trip-hazards are in the space?

~ If cables come out into the space, use cable-matting to cover them. You can use black gaffer tape if you don't have matting.

~ Is your work heavy? Can it fall over and hurt someone? Can you secure it (drill it into the floor / brace it against a wall)?

~ Make sure all fixings are secure.

~ Don't block/obstruct fire escapes and escape routes.

> *I know that many will call this useless work.*
> **Leonardo da Vinci**

Finishing

~At some point you have to finish and start tidying up for the private view.

~Appoint someone/remind yourself to get this started with enough time to spare.

~Sweeping: It is best to sweep regularly during the install. This saves on dust and makes the job much easier at the end – it also stops too much build-up of dust.

~It may seem mad to say it but there is a way to use a broom properly:

 ¬ Outdoor brooms are coarse and work better if pushed.

 ¬ Indoor brooms have a finer bristle and work better if pulled.

 ¬ If you have a lot of dust which you cannot afford to go swooping about the room, use a misting bottle (like a window cleaner bottle) to spray water near to the floor. When you sweep, the water droplets will pick up the dust. This does, however create 'mud' so you will need to mop afterward.

General tips

~Get your own tape measure! (Have I said this before?)

~Always clear away tools and bits-and-pieces at the end of the day. Have a good sweep up and empty the bin if you can.

~You can use a large (10-12mm) drill bit to countersink a hole if you don't have a special bit. Use a metal bit ideally but be careful not to go too far in!

~Never open a paint tin with a good chisel (you will go to carpentry hell). Always carry at least one sharp wood chisel for wood ONLY and carry a blunt old knackered chisel for everything else.

~Do not rely on power tools (drill/driver for example). Always keep a selection of hand screwdrivers about your person – you never know!

~Hold (or get someone to hold) a vacuum cleaner hose next to the drill bit while
 drilling in the space – NO dust!
~If on your own and drilling into masonry: lick (the corners will do) and stick an
 envelope to the wall below the drill point, fold open a little, and catch all the dust.

~ Rolling a cable – please try to learn this one:
www.youtube.com/watch?v=-74OEVUOKOw

~ A '*rawl plug*' is a 'wall plug' – *Rawl* is just a brand name that has caught on.

~ If drilling to a specific depth, wrap a piece of masking tape around your drill bit at the relevant spot so you know when you have got to that depth.

~ If you use a cheap paint-brush, some bristles will fall out during painting and attach to the painted surface. They are easily removed by approaching perpendicular to the offending bristle while the paint is still wet and 'scooping' at it with the brush. The loose bristle will usually stick to the brush and come away from the surface – remove by hand from brush and wipe on back of trousers. It's then easy to make a couple of little clean-up strokes to make good.

~ Use art college to meet like-minded people – a supportive network is going to be a massive thing outside and inside the studio.

~ If you are new to a city, get a job/volunteer at a good contemporary art institution – this is a great way to meet other artists and art professionals, to get to know how the city works, and the galleries or project spaces that are interesting.

~ Take responsibility for your work. The media you choose to work with are your responsibility. You can expect a measure of support from any institution you are working with, but it is up to you to know what needs to be done, and how to do it.

~ The art world kind of works on recommendations. The best people trust the recommendations of good artists – they are on the ground doing the essential work. You wouldn't ask a jeweller where to mine for gold, would you?

Further reading: Pete Smithson's: *Installing Exhibitions – A Practical Guide* (A&C Black)

GALLERIES / CURATORS / DIY

GALLERIES

For the purposes of this section, we are thinking of shows in galleries – not gallery representation. [see Selling section for more about long-term relationships with galleries]

~If you are invited to be part of a show in a gallery space, it is usually for one, or both, of these reasons: a curator/artist of theirs likes your work; and/or the gallery is interested in the art you make and wants to see how you work, what you are like, how strong the art is (and your relationship with it), how potential collectors and their buyers might react to it. Either way, try to make a good impression.

~Be professional – know what your art needs. Send images and text when they ask you. Do what you say you are going to do.

~Invite your own contacts, people you want to see your work, and potential buyers to the show.

~Be charming.

~Showing in museums – brilliant. Lots of artists moan about it though: lots of work, little money, few sales, exhausting. But this is the big time, baby! Enjoy.

CURATORS

~One of the best ways to get your work seen is to get curators interested in it. Remember not to be too obtrusive or pushy when approaching them. Always remember that curators have their own interests and specialisms.

~They are less dependent on sales than galleries need to be, so they can be more interested in less sellable work, and do more exciting shows.

~ Most colleges have a curating course – if you are at college with them, get to know them, talk to them, see if you like them. These are often the curators of tomorrow.

~ Invite the curators whose work you like to your shows (invite them to your degree show!) – make the invitation personal and tell them why you like what they do. When you know them a bit better, you can invite them to your studio, but inviting them to a show is always a good first step – it is less pressured.

~ However you approach them, it is best to be upfront and honest about the fact that: you are interested in their curating/work/organisation/ideas; you would like to discuss your own work to get their feedback.

~ You need to be able to trust a curator – there are really two kinds: those who know what art is, and those who don't. If they know what art is, they will put it first. If they don't, the show will be about them – their interests, their 'themes', their cool. Stay away. Additionally, there is now an alarming trend for some curators to omit the names of participating artists from publicity, invites, press releases, labels, etc. It is essential that this not become accepted practice. Always check early on that this won't happen. If it is the curators' intention, make them change their minds, or stay away.

~ Working with a curator should be a reciprocal thing. It is important not to see them, or treat them, as administrators or marketing people for your work, but more like colleagues who are taking an interest in your work for their own study.

~ Find out what they like about your work, and try to have a meaningful engagement with them. They will appreciate this, and also it will help them to represent your work in the best way possible for you. (Also the more interest and understanding of your work they have, the more time and space they will dedicate to you in their

own work). You can also share ideas, and it is more likely that these ideas will spur on future collaborations.

www.youtube.com/watch?v=PUoUszh98P4

EXHIBITION DIY

~ The galleries that hire themselves out for external shows are usually known for less-than-excellent art. If you want to DIY, look for an interesting space. If you want a white cube, do the work to turn it into one as much as you can.

~ Showing in your home or studio will cost nothing in rent and save you having to find a space. Check you are allowed to invite the public into your studio block. Take into account the space – this is not a gallery and will never look like one – do interesting stuff. The Hex started in the spare room of Maria Zahle and Jason Dungan's council estate flat: interesting stuff: www.mariazahle.bulldoghome.com

~ Shops, warehouses, factories, car parks, hospitals, launderettes, parks, municipal buildings, gardens, hotels, swimming pools, sports centres... If they are still working venues, bear in mind the principal use of the venue and the needs and wishes of those involved, taking these into account when first approaching them.

~ Before approaching anyone about using their property, do some research on their organisation, the individual and the area. Think about what benefits you might be able to offer them and what they might see as disadvantages. Have a clear idea in mind of what you want to do, how much time you need, some idea of the costs involved and how much you are prepared to spend.

~ Draft a simple proposal. Write a letter to accompany this explaining your ideas. Suggest that you meet to discuss the idea.

~ To many property owners, this will be a new idea. Be prepared for the process to take some time – those concerned may take some persuading. If you have no luck, try to gain some idea of what their objections are. This can provide some useful hints for future approaches.

~ There are many advantages to doing group shows: sharing costs, work, invigilation, knowledge, experience, skills and contacts. Showing in a group widens your audience. You may also find it easier to approach people for support on behalf of a group.

Insurance

~ Get it!

~ At the very least, public liability insurance – if anything happens to anyone in the space, you need this to cover you.

~ You might want to insure your work and equipment against damage and/or theft.

~ AIR membership provides free £5m public liability insurance cover to artists. It also provides low-cost options for studio, contents, artwork, exhibition or a personalised quote against specific needs: www.a-n.co.uk/air_insurance

~ The Society for All Artists also offers their members free public liability insurance, and artwork insurance (they even send you nice samples of watercolour paper): www.saa.co.uk/support/insurance.php

~ Pop Up Space is specifically tailored to assist pop ups and temporary tenants – they offer short term insurance: www.popupspace.com

~ Or you can go to a broker. Brownhills has a specialist art service: www.brownhillgroup.co.uk

Communications

~Press, marketing and communications play a really important part in organising an exhibition. There is a certain amount of promotion required to make it a success on a number of levels: visitor numbers, critical acclaim/press and how the public and art professionals perceive the show and those participating in it.

~Produce a press release as soon as possible. Magazines need long lead times and you want to get something to them early on. Develop the press release concurrently with the exhibition. This means that you can send updated versions and the release gets more and more interesting.

~Arial 11 is the standard font – send the press release in Word (it means they can cut and paste easily) – keep the writing simple and clear – keep images small so that it does not take ages to open on a computer.

~Gather biographical details of participants, high and low resolution images relevant to the project, and any texts or exhibition guides that are produced by the curator or any other contributing person.

~Marketing online is cheaper, more efficient and is a much easier way to reach a wider audience.

~E-invites: the traditional date for a large send-out is two weeks before the opening. Do a reminder/send again a few days before, but don't be tempted to send too many invitations – this just irritates people.

~Compile and maintain your mailing list throughout the exhibition – add/remove press contacts, listing sites, blogs, and enter the contact details from the comment book.

~If you are not using a campaign mailing package from the internet (mailchimp etc.), then remember to respect everyone's privacy and bcc email addresses.

~Social Networking: Obviously Facebook and Twitter, but there are always new online platforms that are emerging. Find them and use them (5 years from now Facebook may be redundant). Start accounts as soon as possible and always engage in conversation about a variety of interesting topics, not just things that concern you directly (no one likes people who just go on about themselves and this definitely applies online as well).

~Online listings: post, post, post. Most are free and will help your SEO (search engine optimisation) when people Google your show.

~If you have a larger budget, you can produce print-based flyers, but this is expensive and you are competing for impact with many of the larger organisations with fancy card and embossing – why kill the trees?

~However you communicate, think of it as developing relationships with people: curators, gallerists, writers, editors, bloggers, socialites, lecturers, and, of course friends and fellow artists.

~If you are having a show, invite everyone whose work you like – curators, gallery people, artists. A show is a great way to get people to see your work. Use the opportunity. BUT…do not spam.

Marketing Campaign

A general schedule is as follows:

¬ 8 weeks before – let press know about the exhibition so, if they are interested, they have time to respond and produce content. Send a personal letter with the press release to editors/writers/freelancers and invite them to cover the project. If you know and like their work, mention it – you might want to mention why they might like your work or why it would be relevant to them/their publication.

¬ 4 weeks before – an intense period, but do not neglect the press side of things. The final press release should be ready and the website or blog should be live. Send a more detailed press release with a press pack to everyone: information on the participants, with images; any extra events and activities that may be of interest; invite them to the Private View.

¬ 2 weeks before: send the email invite to everyone – for the Private View and the show. Make sure dates, times and addresses are correct and clear. Create a Facebook event, continue to tweet. Make sure all listings have the info about the show: for some you need to input the info yourself (Time Out deadline is two weeks before); for others, send the basic info to an email address (the Press Association handles loads of listings, send email to: art@pa-entertainment.co.uk)

¬ A few days before: send reminders to everyone for the Private View.
Send personal letters with the press release to key editors/writers/freelancers. Twitter and Facebook: post reminders and any other interesting, related things, especially other shows you or the other artist(s) may be in.

The Private View

The installation is over and now you are in the spotlight, like it or not. Be a charming host/hostess – I am afraid charm is unfairly important for success in this world. Get over the stress of creating the show; accept that your work is as it is; smile; don't drink too much (to avoid hot-face booze-and-stress reaction, and/or becoming incoherent and tedious); mingle.

It is important to have the event documented, not only for posterity, but it provides interesting material to use online thereafter and for press.

Exhibition Management

~After the Private View you tend to think that the hard work is over, but this is where it all begins. Don't lose focus.

~The press want installation images as soon as possible. Many organisations try to have the show photographed before the Private View, but all too often this is sadly not possible when going the DIY route. Get the work documented as soon as possible after the opening.

~Have enough maps/exhibition texts printed and proof read!

~Have a price list ready, but remember the established etiquette (relating to the primacy of *looking* over *shopping*) is to have this separately and discreetly available.

~Some people like to have a comment book, seeing this as a great way to receive feedback and add contacts to their mailing list. Others prefer to have a book strictly for contact details with no Comments section. Yet others prefer to have no book at all, relying on exchanging details face-to-face, as and when the need and opportunity arise.

~Keep the space clean; visitors attend to see the art, not to be distracted by rubbish on floors/walls.

~You will need some invigilation – even if this has to be you – you have to watch over the art. Remember not to talk too loudly in the exhibition. The visitors have come to see the art not listen to people jabber on about their weekends in a corner – it is very distracting – be professional at all times. Also do not be tempted to accost people coming to see the show. If they want to talk to you, show by your manner that you are approachable.

[Advanced, but important: If visitors want to ask you something that only the art itself can tell them, you may be able to learn to say this to them.]

~ Things to keep on hand:

- [] Batteries – have a supply for remotes, wireless headphones, torches.
- [] Torch – for projection rooms – very useful – especially if your phone does not have a light.
- [] Spare USB sticks
- [] Make sure you have master copies for film and video works. Store these on an external hard drive, not your personal computer.

~ Don't neglect marketing and press – follow up any leads. Send press info that they request as soon as you can – they are often working to very tight deadlines. Maintain the listings. Tweet and share on Facebook.

~ Hosting events is a great way to continue attendance momentum throughout the show. It is also an opportunity for artists in the show to present more aspects of their work.

~ Events can also encourage day visitors to return in the evening, and can add a new element/dynamic to the show and grow beyond the conventional format of an exhibition.

~ At the end of the project, archive all documentation and publicity. Print out features on websites, make them into a pdf, get hard copies from magazines/ newspapers. These should also be digitised: ie, scanned/compiled, etc. Compile the whole archive digitally and in hardcopies.

~ The digital archive should be made available for participants, partners, etc.

~ This will be very useful for future projects you want to present, or when applying for funding.

DOCUMENTATION

~ Document everything you make.

~ Document every show.

~ Factor the cost of documenting any exhibitions into your budgets and if you can afford a professional photographer, get one.

~ Most art schools offer photography workshops – do one before you leave.

~ The best source of light is natural daylight.

~ Avoid using flashes unless you bounce them off something: ceiling, white card etc

~ Get the shot frame parallel to the edges of the work.

~ Don't be tempted by 'arty' shots – a corner of this, a detail of that – show the work, not your photographic skills.

~ Don't over-correct your images – it is so obvious when you have become over-excited with the contrast button!

~ 300dpi TIFF files for print; 72dpi jpegs for email and web.

~ If sending images to view on a screen, they don't need to be huge. Check sizes – even in the age of super-fast broadband, sending huge files is still bad form.

~ Think of a useful filing system for your photographic files – trust me – it will help so much later on. Decide on a cataloguing system (your name/title/date/exhibition/media/reference number/etc.) and stick to it.

~ **Portfolios** – don't use images of a work or project that you consider to be personally important if it is badly documented – no-one else will understand the significance.

~ Throw away pictures of work where we can see your reflection.

~ BACK UP YOUR FILES!

YOUR WEBSITE

CONTENT

This advice is for portfolio websites, not web-based artworks.

~Don't attempt to show everything you have ever done. Be selective.

~Contact – please do include your contact details. Not including them makes you seem aloof. Contact forms are just annoying – if you are worried about spam, list your email address like this: example[at]example.com

~Don't include huge amounts of text explaining your work (unless it is part of it of course) – allow the work to speak for itself where possible.

~Statements – complex ideas can be conveyed with clarity, and clarity is appreciated by others, especially when reading at speed.

~Do include a full CV of shows and your education, if you deem it relevant. Interested parties will look here to gain a sense of how active you are.

~Do constantly update your CV. Test how the document comes across to others and don't get hung up on details rather than overall presentation. Consider also how your web presence matches up to your paper CV.

~Advertising – just don't go there! Keep your site for your work alone.

~Links – it may be tempting to include a page with lots of links to your friends' sites – unless they are collaborators or somehow relevant, don't – keep your site focussed on your work.

~SEO (Search Engine Optimisation) – read up on this to make sure you get the most from search-engines.

BUILDING

~ If you do not have the time and energy to learn HTML, there are several options available to you: Tumblr, Blogspot (good for running updates of news etc), Wordpress, Indexhibit, Weebly, Cargo Collective. Most of these will give you a subdomain site, eg. example.weebly.com. However, for very little money you can upgrade to use your own domain, eg. www.example.com

~ Layout/navigation – whatever you do, make sure your website is easy to navigate. Do not make a labyrinth (unless it is your intention for people to get lost). Always make sure individual pages have links back to your homepage.

~ Homepage – this is the first thing visitors to your site will see, so choose a work or a slideshow that you feel adequately represents your practice.

~ Sounds/video – do not have these play automatically. Give visitors the option of clicking to hear/view.

~ Images – use web-friendly image sizes, around 100KB or less. Adobe Photoshop's 'save for web' feature is good for this.

~ Hosting – don't be tricked into buying a package with huge amounts of storage. Save on hosting by using third-party sites such as YouTube/Vimeo/Soundcloud, and then embedding these as objects on your site.

Put your domain name on your email signature. This is a great way to get your work seen without being pushy.

SELLING

> *We do not make art for the public. We are the public that makes art.*
> **Excerpt from Eastside Projects User's Manual: Draft 5, 2012**

INSTRUCTIONS

- Unless installing your work is very obvious, always send instructions.
- If you want a work shown on a plinth / hung at a certain height – specify this.
- Don't take it for granted that anyone will know which way up it goes.
- Instructions can run from a few words to many pages. Either way, keep it concise, clear, sequential.

Things to think about:

Can someone else install your work? Can it be done by instruction?

Can only you install your work? What will happen when you die?

Is there a trusted number of technicians in the world that can install your work? Name them.

Does your work incorporate replaceable readymades? What happens when these are no longer available? Can they be updated?

Does your work need to get dismantled and re-assembled each time it is shown? Does this matter?

Does it need specific materials when it gets re-assembled?

Does the work develop a life of its own – how much do you have to control it?

There are no right and wrong answers for this – the work will dictate it – but send it out into the world prepared for the future.

EQUIPMENT

Does your work involve equipment?

Think about including this with the work when you sell it – a specific monitor? A 16mm projector?

EDITIONS

- Things you can edition: prints, photographs, casts, performances, films.
- If you are making an edition, think carefully about what you want. You cannot change the parameters of the edition later.
- Smaller editions are more valuable – between 3 and 5 is a kind of standard.
- Two APs (artist's proofs) are generally acceptable.
- In the market, a numbered edition is usually more valuable than an artist's proof.
- One very famous film was sold in an edition of 6 – quite costly they were too. The artist later decided to release the film, so you could buy it for £10. Some people think these things are contradictory, but they are not. Of course they are different – the original 6 own the work as an artwork. They have the right to screen it publicly, exhibit it, and they can sell it as an artwork.
- If editioning a performance, what is being editioned? – the right to perform it? Where? By instruction? Any special audio/video/composition that needs to go with it? Does someone in particular or a certain kind of person need to perform it?
- Be as clear as possible about everything.
- Equally, if something can never be editioned, it is always worth putting this on any paperwork: 'original' usually does the trick.

PRICING

- Look around, go to shows, ask your contemporaries – your prices should be in line with theirs in terms of experience, exhibiting, selling and (roughly) medium.
- Editions are usually less expensive than original works.
- If you are leaving college, your tutors should help you. Don't be shy to ask galleries and good curators you are working with. It is important to get this right.
- Most galleries are not very open about their prices, but you can ask. College degree shows try to sell their students' work – these are good places to ask at for younger artists. The fairs are a great way to get a sense of prices, but of course this is for artists at a certain level – however, you should get a feel.
- Don't be tempted to go too high too quickly. Galleries are very careful about putting their artists' prices up – you can never really put them down.
- Be consistent – prices for your work should be the same no matter where you are selling. This does not mean you cannot negotiate discounts, but the price should be the price, from your studio/a gallery/a fair.
- Of course, if you are represented by a good gallery, you can be guided by them.

COMMISSIONS

- Things to think about:
 - ¬ Where and how will you be identified as the artist?
 - ¬ Who actually owns the work?
 - ¬ If you do not not own the work, can it be moved/demolished/altered?
 - ¬ Work maintenance and care – are there instructions? Who is responsible?
 - ¬ How and when will you be paid?

- It is not unusual to ask for up to half of the commission fee upfront for materials.
- Have a written agreement.

GALLERY REPRESENTATION

- There is no magic trick to this: do your thing, do it well, get it seen in independent spaces. *If you build it, they will come.*
- Generic proposals for exhibitions, internships or other opportunities are easy to spot and rarely responded to.
- Approaching galleries – if you are sending an unsolicited proposal to a gallery, ask yourself:
 ¬ Have you researched their current programme?
 ¬ Do you have a named person to send it to?
 ¬ Are you clear about why you are approaching them, and have you considered how you might make yourself appear relevant to their concerns?
 ¬ Is their programme focused on solo exhibitions or groups shows?
 ¬ Do they tend to exhibit young artists or focus more on those who are mid-career?
 ¬ Is the gallery especially suited to the kind of work you are proposing and have you visited or engaged with them in any other way?
- Galleries get so many requests from artists – don't just spam them. Choose the galleries you want to work with and tell them why. The best is to be able to invite them to a show. If you can't, send them a portfolio and biography (or website links). Don't send too much stuff. Don't be disheartened if they don't respond – galleries hardly ever take on artists this way. It can be worth trying a few times, but only if there are developments which you can update them on/invite them to.

- Get your website sorted out: simple and strong is good – the better your online presentation, the greater the chances that people will at some point want to see your art in the flesh.
- Gallerists listen to artists in their stable and to artists they respect.
- Galleries want to know that you are serious about your art and committed to it. They are looking for long-term relationships.
- Ultimately you want a gallery to propose to you – not the other way around.

WORKING WITH GALLERIES

- Don't just go with the first gallery that wants you – you need to respect them and believe in what they are doing just as much as they need to respect and believe in you.
- Find out about a gallery thoroughly before signing with them – talk to their other artists, look online, ask around.
- Most galleries take a 50% commission on the sale of consigned art. That's a lot, but they also do a lot. In an ideal world they should:
 - ¬ catalogue images
 - ¬ help with storage
 - ¬ develop relationships with collectors
 - ¬ find other galleries to represent you
 - ¬ insure your art on their premises
 - ¬ take your work to fairs
 - ¬ enable or pay for shipping to collectors and exhibitions
 - ¬ seek commissions
 - ¬ assist with your career development

¬ pursue museum shows

¬ track sales

¬ sell your work

- Lots of smaller galleries simply cannot afford to do as much for you as established outfits. They are often just managing to pay the rent on their space and working for pretty much nothing because they believe in art and what they are doing. Be willing to take this into account. Galleries can be emerging too.
- Hopefully you are entering a lifelong relationship. Every one of these needs trust, mutual respect and appreciation.
- Understand what is expected from both parties.
- Clear, open and on-going communication is essential to any successful artist/ gallery relationship.
- If you don't trust your gallerist, you should not be working with them. Accept that their side of your career is showing and selling – listen to them about this. Equally, you don't have to take shit from them telling you how to make art.
- Don't sell work behind your gallerist's back. This is a partnership – keep up your end of the deal.

A lot of people ask about whether a contract is important with a gallery. Some people insist that it is, but the reality is the art world, particularly in the UK, is still very much run along the lines of a gentleman's agreement. You have to decide if you are comfortable with this, and remember you have to keep your word as much as the gallery does. It is always worth having something written about which works are consigned to the gallery and when – at the very least in an email.

(See more about Contracts below and in the Q&A)

LEGAL ISSUES

These tips are not for the purpose of providing legal advice. You should consult a solicitor for advice on specific matters.

CONTRACTS

A legal contract is always the way to go. If you cannot do this, get as much as possible in writing: a written agreement; a clear exchange of emails; a signed napkin with notes...

A legal contract has four elements:

☐ the offer
☐ acceptance of the offer
☐ consideration (what is paid – remember this does not have to be money)
☐ the intention to create a legal relationship

If one of these is missing then you don't have a contract!

Have you ever had to agree to pay one peppercorn for something? This is the consideration – without some form of it, there is no legally binding contract.

INTELLECTUAL PROPERTY

Intellectual Property (IP) is quite a broad term, but it covers the 'creations of the mind' (got to love that phrase). It is your rights over what you have created: what you have created is legally viewed as your *property*.

You have the right to manage how your work goes out into the world, how it is treated, and how it is represented.

For artists, the three main aspects of Intellectual Property are: Copyright; Moral Rights; Resale Rights.

Copyright

- The right entitles you to benefit economically from the reproduction of your works.
- You automatically own copyright of your work and it lasts for your full lifetime and 70 years after your death.
- Copyright can be 'assigned' or 'licensed'.
 - ¬ Assigning your copyright means you can never get it back and will have no future rights to it. You will also not have control over the way in which your artwork is used.
 - ¬ Licensing your copyright is granting permission to use your artwork. You can decide in which way it is used and for what purpose. You can license the same artwork for various uses.
- Things to be wary of: reproduction quality (especially colour); that others should not manipulate or montage your images; that credits and work details are accurate.
- If you don't want to deal with it yourself, DACS (Design and Copyright Society) www.dacs.org.uk can represent you worldwide, negotiate prices and rights, and pass on your royalties minus an administration fee.

Moral Rights

- These rights allow you to protect how your work is seen – you can legally object to any modification, deformation or mutilation of the work.
- They also protect your right to be identified as the artist.

LEGAL ISSUES

- The laws are different in each country: In the UK these rights last the same length as (economic) copyright. In the US they cease upon the artist's death. In France they last forever.
- You can waive your moral rights.
- Unlike copyright, they cannot be assigned or licensed.

> *Independently of the author's economic right, and even after the transfer of the said rights, the author shall have the right to claim authorship of the work, and to object to any distortion, mutilation or other modification of, or other derogatory action in relation to, the said work, which would be prejudicial to his honour or reputation.*
>
> **Copyright and Designs and Patents Act, 1988**

- As artists experiment with the bounds of traditional media, it is important to note that moral rights do not cover computer programs, material used in newspapers and magazines, or reference works like encyclopaedias and dictionaries. I look forward to the court case in which these rights are asserted for a computer program as a work of art – won't the court transcripts be interesting?
- An important spin-off of this right is a question of restoration and conservation. If anyone has interfered with your work, you can essentially disown it. Always send detailed instructions with your work, along with maintenance plans, and think about what will happen to your estate after your death.
- In contracts, address the issue of conservation and restoration – does this need to happen with your authority? Can restoration happen at all? Best practise is

that any future owner should ask your permission before embarking on any restoration works.

Resale Rights

- The Artist's Resale Right (also known as Droit de suite) means that you could be entitled to a royalty when your work is sold for over €1,000 on the secondary market.
- The work has to involve participation by an 'art market professional' i.e. a dealer/ gallery/auction house.
- ARS only applies to works sold in the European Economic Area (EEA).
- Works must be original works of art or limited editions made by the artists themselves, or under their authority, including "works of graphic or plastic art such as pictures, collages, paintings, drawings, engravings, prints, lithographs, sculptures, tapestries, ceramics, glassware and photographs", and under copyright protection.
- Your royalty is worked out according to a sliding scale from 4% to 0.25%.

Portion of the sale price	Royalties
From 0 to €50,000	4%
From €50,000.01 to €200,000	3%
From €200,000.01 to €350,000	1%
From €350,000.01 to €500,000	0.5%
Exceeding €500,000	0.25%

- This scale is cumulative, so if you reach more than one of these thresholds, you will get that amount at that percentage – add these all up to get the final sum.
- The maximum royalty is capped at €12,500.
- In the UK you can only claim resale royalties through a collecting society.
 DACS (Design and Copyright Society): www.dacs.org.uk
 and
 Artists' Collecting Society: www.artistscollectingsociety.org
 are the two main UK collecting organisations.
- The right lasts the same length as copyright: the artist's lifetime and 70 years after the artist's death.
- This is an inalienable right – you cannot choose not to have it, or give it up, and no-one can take it away from you.
- Forms of the right were first introduced in France inspired by Jean François Millet's wife living in extreme poverty whilst his works were selling for fortunes.

The Intellectual Property Office offers this information booklet:
www.ipo.gov.uk/businessguidance.pdf

SELF-EMPLOYMENT
These tips are not for the purpose of providing tax, financial or employment advice. You should consult HMRC for advice on specific matters.
- Self-employment for artists usually makes the most sense – when you are earning megabucks, ask your accountant about the best way to go about things.
- This will cover sales of your works, one-off jobs, temporary contracts, freelance work, and awards. If an employer is not paying tax for you, you have to pay it.

- If you are registered as Self Employed, every year you will need to fill in a tax return (Self Assessment form) to notify HMRC:
 ¬ how much you have earned as self-employed
 ¬ how much you have earned where tax has already been taken off (from your P60)
 ¬ expenditure on your business (eg: studio, materials, phone, internet, equipment, travel, professional fees, etc.)
 ¬ They will calculate what profit/loss you have made and how much tax you owe.
 ¬ It is easiest to do all this online.
- If you are lucky enough to be able to forge a living wage from your work, get a good accountant. A good accountant, and preferably one who has knowledge of working within the arts, will save you money and hair-pulling when it comes to completing your tax return.
- If you can afford one, get a bookkeeper to deal with your day-to-day paperwork and finances. This will allow you to think about your creative output rather than your taxi and lunch receipts!
- Accountant's fees, like other professional fees to support your practice, can be offset against your income.
- If you aren't earning enough money to justify the expense of an accountant, make sure you keep good, clear records of your earnings and expenses.
- DO keep monthly accounts – a simple spreadsheet of your outgoings and incomings will suffice, along with copies of any invoices.
- Keep all expense receipts in one place and preferably make sure you check these against your accounts on a monthly basis – again, this will save you time and hair-pulling once the deadline for your tax-return comes around.

- Also bear in mind that HMRC can audit anyone self-employed at any time and that they WILL want to see good, clear finance records and can fine you if you are not able to demonstrate that you have the right paperwork.
- Take the time to look up taxable expenses on the HMRC website – you may be surprised about what you can and can't claim as taxable expenses, particularly if you work mainly from home.
- If you think you aren't earning enough to go to the trouble of registering as self-employed, DO bear in mind that any company that has paid you for work can be audited by HMRC. An audit will mean checking all payments made to performers or artists and may mean HMRC checking to find out if you have declared your earnings.
- DO keep enough money aside to pay your taxes – sadly, HMRC may not be very sympathetic if you don't have enough money to pay taxes due at the end of the year, and you may be fined for late payments (with interest!).

HMRC Notes on registering as self-employed:
www.hmrc.gov.uk/selfemployed/register-selfemp.htm
HMRC Notes on Self Assessment: www.hmrc.gov.uk/sa/index.htm
Business Link's Guide: www.adviceguide.org.uk/england/life/tax/income_tax.htm

'Networking' is just an 80's power-word for talking to people.
ACME

Q&A WITH ALANA KUSHNIR

Legal Basics – What To Think About When Producing And Distributing Art

Disclaimer: The content in this section has been provided for informational purposes only and not for the purpose of providing legal or employment advice. It should not be used as a substitute for specific legal advice or opinions. You should contact your lawyer to obtain advice with respect to any particular legal issue or problem.

Sometimes the last thing you want to think about is the legal stuff. You may have already expended all of the blood, sweat and tears that you can muster when getting your project off the ground, submitting a proposal for an open call or dealing with a gallery which wants to exhibit your work. You might think to yourself: what's the risk, really? Isn't this a simple case of spending money which you don't have? And who knows what a covenant is anyway?

Well, here's hoping you will be able to sleep a little easier after reading through this checklist of questions, which you can use when you produce and distribute your art. It includes suggested resources which you can consult for more information.

You may notice that many of the questions relate to contracts. If you don't have the time to make or deal with fancy legal contracts, at the bare minimum you should make sure that all of your communications are clearly documented. Never leave discussions about your, or someone else's, rights and obligations as pure oral communications. It's certainly OK to conduct discussions about legal

issues in person, over Skype and on the phone, but make sure you immediately send everyone involved a follow-up email which records the main outcomes of the discussion. If you don't make this effort, it may lead to miscommunications and disagreements over who promised to do what down the track. This is an easy strategy which will save you on many occasions.

PRODUCTION QUESTIONS

How can I protect my work from being used by other people in ways which I don't want?

Intellectual property (IP) is the answer for you. You should think first about copyright. You should think also about your moral rights and other areas of IP that might be relevant too, such as trademarks, patents and design.

The UK government has an Intellectual Property Office and its website, www. ipo.gov.uk contains plenty of information about what constitutes intellectual property, and about other protections such as moral rights, performers' rights, the publication right and the database right, as well as how you can register your trademarks, patents and designs.

For suggestions on how to maximize your IP, have a read of this IP strategy pamphlet written by the City Enterprise Service: http://www.city.ac.uk/__data/ assets/pdf_file/0004/133933/Intellectual-Property-Strategy.pdf

Someone has asked to use an image of my work. Should I say yes?

While this may sound obvious, you should probably find out exactly what the person intends to do with the image before you give permission to use it. When you

permit someone to use your IP, this is usually called an assignment or a license. The best way to make sure that people use your IP in a way which you are comfortable with, is to ask them to sign an IP licensing or assignment contract.

You can find contract templates relating to IP at http://www.own-it.org/contracts and at http://www.contractstore.com.

I want to use an image I have found online. Do I need to ask for permission?

Don't forget that someone else might have copyright or other IP rights in that image. Asking for permission is an easy and efficient way to avoid what could potentially be an infringement of someone else's legal rights.

There are some situations in which you might not need to ask for permission. You can find more information about this on the UK IPO website (referred to above), by reading Own It's Guide to IP Rights, which is at http://www.own-it.org/knowledge/the-ip-guide-to-visual-art and the articles on using other artists' work at http://www.artquest.org.uk/articles/view/using-other-artists-work.

I am being commissioned to create a new work. Do I need to sign the commissioning contract I've been given?

It is in your best interests to sign a commissioning contract. But that doesn't mean that you should necessarily sign the document you have been given, especially if you don't agree with everything in it.

Don't be fooled into thinking that there is such a thing as a standard contract which cannot be changed before you sign up to it. There isn't. You always have the

right, just as much as any other person signing the contract, to change it, or remove something or insert something different.

Asking yourself the question: "who needs who more?" will be a good indicator of assessing your negotiating power and therefore your ability to amend the drafting of the contract.

For a step-by-step guide on commissioning contemporary art with more information on the legal aspects, have a read of the book Commissioning Contemporary Art: A Handbook for Curators, Collectors and Artists by Louisa Buck and Daniel McClean.

You can find a template commissioning contract here: http://www.artquest.org.uk/articles/view/commissioning-an-artist1

DISTRIBUTION QUESTIONS
A gallery wants to show my work. What kind of contract should I sign?
The type of contract you should sign with a gallery depends on what the gallery is offering you. If the gallery wants to represent you, then you should sign a Gallery Agreement. You can find more information on what a Gallery Agreement should include here: http://www.artquest.org.uk/articles/view/gallery-agreements1

If the Gallery wants to sell a work of yours on your behalf, which is in an exhibition of theirs, then you should sign a Consignment Agreement. You can find a template Consignment Agreement here: http://www.artquest.org.uk/articles/view/contracts-with-galleries1

If the Gallery does not intend to sell your work or represent you, but wants to include your work in a one-off exhibition, you should still sign a contract where you agree to the terms of the arrangement. You can find a template for an Exhibition Agreement here: http://www.artquest.org.uk/articles/view/exhibition-agreements1

A collector wants to buy my work directly. What should I make sure is in the contract of sale?

This depends on what your concerns are. For example:

- ¬ Do you want to ensure that the buyer takes proper care of the work?
- ¬ Do you want to have a say on how and where the buyer agrees to exhibit the work?
- ¬ Do you want to be able to make more editions of the work without asking the buyer?
- ¬ Are you concerned about the risks of transporting and insuring the work?

You shouldn't just discuss your concerns with the buyer at the point of sale. You should make sure that you come to an agreement with the buyer about each of your terms and record these terms in a written contract signed by you and the buyer.

One of the classic templates for a contract of sale between an artist and a buyer is The Artist's Reserved Rights Transfer and Sale Agreement. You can get a copy of it here: http://primaryinformation.org/files/english.pdf

I want to submit my work to a Call for Entries, but there's a bunch of terms and conditions they've asked me to sign. Do I need to sign them?

When you agree to terms and conditions, you are essentially signing a contract. This means that if you break terms and conditions that you have agreed to, there can be serious consequences. Generally, the terms and conditions will list what those consequences are, so read them!

The Bill of Rights for Artists campaign provides information on artists' rights in relation to works they submit to creative competitions, including licensing work for use by the competition organisers. See http://artists-bill-of-rights.org

Do I need to be registered as self-employed if I am selling my artwork?

In the UK, if you are selling your art then you need to register as being self-employed. By selling your work you are trading and therefore you are responsible for paying your own income tax.

You can find information about how to register for self-employment, as well as other icky tax stuff like VAT, National Insurance, importing and exporting, on the HM Revenue & Customs website, http://www.hmrc.gov.uk

Artquest also has a number of articles on how to make a living at http://www.artquest.org.uk/articles/view/money5

Alana Kushnir is a freelance curator and researcher who has recently graduated from Goldsmiths, University of London with an MFA in Curating. Prior to this, she was a practising lawyer.

FURTHER ADVICE

Unfortunately, this checklist is by no means definitive, nor does it touch upon many legal issues which you should consider in any given circumstance. You may still need to get legal advice which addresses your particular situation. Luckily, it might be possible for you to get free legal advice on art-related issues. Some organisations which may be able to help you are:

- Artlaw provides free online legal advice and information service for visual artists who live and work in England. www.artquest.org.uk/articles/view/art_and_the_law

- Queen Mary Legal Advice Centre, part of the University of London, provides free in-person legal advice to people working in the creative industries once a month during term time. www.advicecentre.law.qmul.ac.uk/arts/index.html

- City Enterprise Service, part of City University London, is a free walk-in centre that offers business and legal assistance to small businesses. www.city.ac.uk/law/careers/pro-bono-professional/information-for-clients/city-enterprise-services

- Lawyers Volunteering for the Arts is a pro bono legal project set up by a group of London-based law firms offering free legal services to low income and non-profit arts and community organisations. http://lvfa.org.uk

- Free Law Direct, a free online legal advice service which provides access to volunteer lawyers for charities and non-profit organisations. http://freelawdirect.org.uk

- Own-It, funded by the University of the Arts London, provides intellectual property advice through an online enquiries system. http://www.own-it.org

- DACS Copyright Advice Service provides over-the-phone advice for artists and beneficiaries signed up to their Copyright Licensing and Artist's Resale Right services. http://www.dacs.org.uk

"Let's build an artworld in the image of the hairdresser. The hairdresser attacks the way things are. The hairdresser ploughs through facts with the not-yet. The hairdresser scours reality with alternatives. The hairdresser makes systematic mercenary war on what in fact is. This is why even the most perfectionist hairdresser is ultimately on the side of wildness. The hairdresser trims individualistic and indisciplined growths into unified planned wholes and truth bearing events." — Freee, 2010

Excerpt from Eastside Projects User's Manual: Draft 5, 2012

LONDON

Studios

Acme: acme.org.uk
Acava: acava.org
ASC: ascstudios.co.uk
Bow Arts: bowarts.org
Cell: cellprojects.org
SPACE: spacestudios.org.uk
V22: v22collection.com

Interesting smaller providers

no.w.here: no-w-here.org.uk
Chisenhale Studios:
 chisenhale.co.uk
Cubitt: cubittartists.org.uk
Gasworks: gasworks.org.uk
Studio Voltaire:
 studiovoltaire.org
The Sunday Painter:
 thesundaypainter.co.uk
The Woodmill: woodmill.org

Materials

Atlantis: *general art supplies:*
 atlantisart.co.uk
Jacksons: general art supplies:
 jacksonsart.com
A.P. Fitzpatrick: *general art supplies:*
 apfitzpatrick.co.uk
Condell: *general building supplies:*
 condell-ltd.com

DK Holdings: *abrasives, diamond
 tools:* dk-holdings.co.uk
Clerkenwell Screws: 109
 Clerkenwell Rd, EC1R 5BY
R.K. Burt & Co.: *paper:*
 rkburt.com
John Purcell: *paper:*
 johnpurcell.net
Shepherds: *Paper:*
 falkiners.com
London Centre for Book Arts:
 londonbookarts.tumblr.com
Wyvern Bindery: *bookbinding:*
 wyvernbindery.com
Hamar Acrylic: *perspex:*
 hamaracrylic.co.uk
Whitten Timber:
 whittentimber.co.uk
Blackburns Metals:
 blackburnsmetals.com
Parkside Steel:
 parksidesteel.uk.com
Hub Le Bas: *tube metal:*
 hublebas.co.uk
Rimex: *fancy steel:*
 rimexmetals.com
Tiranti's: *everything 3D:*
 tiranti.co.uk
Jacobsons: *moulding, modelling:*
 jacobsonchemicals.co.uk

Ceramatech: *ceramics:*
 ceramatech.co.uk
Gerriets: *screens, fabric:*
 gerriets.co.uk
Russell & Chapple: *screens, fabric:*
 russellandchapple.co.uk
Flints: *specialist set-up stuff:*
 flints.co.uk

Printmaking

East London Printmakers: *open
 access:* eastlondonprintmakers.
 co.uk
Sonsoles Print Studio: *open access:*
 sonsolesprintstudio.co.uk
London Print Studio: *open access:*
 londonprintstudio.org.uk
Intaglio Printmaker: *supplies:*
 intaglioprintmaker.com
Wicked Printing Stuff: *supplies,*
 wickedprintingstuff.com

Fabricators

John Jones: johnjones.co.uk
Julian Emens:
 julianemens.com
Matt Blackler: *most things, specialises
 in metal:* matt_blackler@
 hotmail.com
London Mould Makers:
 londonmouldmakers.co.uk
Bucktron: *moulds:*
 bucktron.net

Display Graphics: *mounting, printing, laser cutting:* dispaly-graphics.co.uk

Solid Models: *2D to 3D:* solidmodels.net

Big Soda: bigsoda.co.uk

Felix Wentworth: felixwentworth.com

The White Wall Company: thewhitewall.co.uk

Mike Smith: mikesmithstudio.com

3D general

Pangaea Sculptors' Centre: pangaeasculptorscentre.com

London Sculpture Workshop: londonsculptureworkshop.org

Foundries

Art-specific

AB Fine Art Foundry: abfineart.com

Bronze Age: bronzeage.co.uk

Mid-range

Whitton Casting: whittoncastings.co.uk

James Hoyle & Son: jameshoyleandson.co.uk

Industrial

East Coast Casting: eastcoastcasting.co.uk

Sound

Resonance fm: resonancefm.com

Soundfjord: soundfjord.org

IMT: imagemusictext.com

Café Oto: cafeoto.co.uk

Holkham Sound Design: holkhamsounddesign.blogspot.co.uk

School of Sound Recording: s-s-r.com

Film & Video

David Leister / Kino Club: *film equipment, expertise:* kinoclub.co.uk

no.w.here Lab: *film lab, printing:* no-w-here.org.uk

PresTech: *film services:* prestech.biz

i dailies: *printing, telecine:* i-dailies.co.uk

The Wide Screen Centre: *film accessories, telecine:* widescreen-centre.co.uk

KS OBJECTIV LLP: *film and digital:* ksobjectiv.com

Projector Point: projectorpoint.co.uk

The Block: *monitor hire:* the-block.org

Film and Video Umbrella: fvu.co.uk

Exploding Cinema: explodingcinema.org

LUX and LUX Associates: lux.org.uk

British Artists' Film and Video: studycollection.org.uk

Film London: filmlondon.org.uk

Services: eyecollective.net

Performance

Live Art Development Agency: thisisliveart.co.uk

Arts Admin: *general, rehearsal space:* artsadmin.co.uk

Performance Matters: thisisperformancematters.co.uk

The Performance Studio: theperformancestudio.co.uk

Bethnal Green Working Men's Club: *venue/rehearsal:* workersplaytime.net

LUPA - Lock Up Performance Art (London): facebook.com/LUPA.E2

Chisenhale Dance: *rehearsal space:* chisenhaledancespace.co.uk

Motel de Nowhere: *rehearsal space:* moteldenowhere.wordpress.com

]PerformanceSpace[: *rehearsal space:* performancespace.org

Ceramics

The Ceramics Studio: *open access:* theceramicsstudio.co.uk

David Richardson: *moulds* cpceramics.co.uk

Photography

Metro Print: metro-print.co.uk

Rapid Eye: *darkroom, services:* rapideye.uk.com

London School of Photography: lsptraining.co.uk

Process supplies: processuk.net

Documentation

Noah Da Costa: noahdacosta.com

Alistair Levy: alastairlevy.net

FXP Photography: avvg52.dsl.pipex.com

Andy Keate is brilliant for exhibition documentation.

Transport

Michael Young: ajmremovals@ hotmail.co.uk

OTT Art Transport: ottlondonltd@ btconnect.com

Van Girls: vangirls.co.uk

Non-specialist: packsend.co.uk

Rawlins: *7 ton, with driver:* 020 8293 4248

Jayhawk: jayhawkltd.f2s.com

Martinspeed: martinspeed.com

Williams and Hill: williamsandhill.com

Lightning Packaging: lightningpackaging.co.uk

Accounts: *bookkeeper:* Andie Brown· andiebrownbookkeeping.com

Framing

Oaksmith: oaksmithstudio.co.uk

John Jones: johnjones.co.uk

Mouldings: djsimons.co.uk

Also

NECA: *best art map:* newexhibitions.com/

BRIGHTON

Studios

APEC Studios: apecstudios.co.uk

Coachwerks: coachwerks.org.uk

Phoenix: phoenixbrighton.org

Red Herring: redherringstudios.org

Trafalgar Works: trafalgarworks.co.uk

Materials

Brighton and Hove Plastics: *fabrication, laser cutting:* brightonandhoveplastics.co.uk

Art supplies

Student Union Shop, University of Brighton: Grand Parade campus

T N Lawrence & Son: *general art supplies:* lawrence.co.uk

Alsford Timber: alsfordtimber.com

Brighton & Hove Wood Recycling Project: woodrecycling.org.uk

North Road Timber: *cheap offcuts and scraps:* northroadtimber.com

Fabricators

Artistic Metalworks: *will do bespoke:* artisticmetalworks.co.uk

Brighton Sheet Metal: *powder coating:* brightonsheetmetal. co.uk

Pipecraft: *metal fabricators:* pipecraft.co.uk

Casting
Harling Foundries:
 harlingfoundry.co.uk

Sound
SCAN: scansite.org
Uni - sound arts BA:
 arts.brighton.ac.uk
Brighton Media Centre: *studio to hire:* mediacentre.org

Film & Video
Lighthouse: lighthouse.org.uk
Cine Conversions:
 cineconversions.co.uk
The ISEA: isea-web.org
SCAN: scansite.org
Wired Sussex:
 wiredsussex.com

Performance
Blast Theory:
 blasttheory.co.uk

Ceramics
Biscuit Studios: *ceramics workshop/ studio:* biscuitstudio.co.uk
Hesketh Potter's Supplies:
 heskethps.co.uk

Printmaking
Ink Spot Press: *open access studio:* inkspotpress.co.uk

Coachwerks: *screenprinting studio:* coachwerks.org.uk
North Star Print Studio:
 northstarprintstudio.wordpress.com
Brighton Independent Printmakers:
 bip-art.co.uk

Photography
Clocktower Cameras:
 clocktowercameras.co.uk
Lighthouse: lighthouse.org.uk
Photoworks:
 photoworksuk.org
The Vault:
 thevaultimaging.co.uk
Coachwerks: *darkroom:* coachwerks.org.uk
Workflow:
 workflowstudio.co.uk

Transportation
Cube Fine Art Services:
 cubefineartservices.com
Man-van: man-and-van-brighton.co.uk

Good stuff
fabrica.org.uk
e-permanent.org
phoenixbrighton.org

BRISTOL

Studios
Spike Island: *get a studio here if you can!:* spikeisland.org.uk
BV Studios: *Viz used to be printed here!:* bvstudios.co.uk
In Bristol Studios – *studios, open access woodwork, ceramics, printmaking:* inbristol.org
The Island: *(not to be confused with Spike Island)* theislandbristol.com/artists-studios.html
Jamaica Street Studios:
 jamaicastreetartists.co.uk
Maze Studios:
 mazestudiosbristol.com
Mivart Street Studios: *bit of a mix:* mivartartists.co.uk
The Motorcycle Showrooms: *sometimes offer studio space in return for volunteering/skills:* themotorcycleshowroom.tumblr.com
Picton Street Studios: *new centre:* pictonstreetstudios@live.co.uk

Materials
Bristol Fine Art: *general art supplies:* bristolfineart.co.uk
Harold Hockey: *general art supplies:* haroldhockey.co.uk

Art@Bristol: *general art supplies:* artatbristol.co.uk

Bristol Wood Recycling Project: bwrp.org.uk

Eastmans and Co. Timber Ltd: eastmantimber.co.uk

Scadding: scadding-son-ltd.co.uk

Aaron Metal & Plastic Supplies Ltd: aaronmetals.co.uk

Laserit: *laser profiling, general metal fabrication:* laserit.co.uk

Fabricators

Plenderleith & Scantlebury: *specialist art fabricators, mould-making, casting:* plenderleithscantlebury.com

Casting

Opus Studio: non-metals: *mould-making, casting:* opus-studio.com

Foundries

Art-Specific

Pangolin Editions: *lost wax, two-part (can do very large works):* pangolin-editions.com

Millers Farm: *lost wax, two-part, Forest of Dean, Gloucestershire*: millersfarm.co.uk

Mid-Range

Bristol Foundry: *to cast iron;* bristol-foundry.co.uk

Sound

The Station: *recording studio to hire:* thestationbristol.org.uk

PK Music: *will trade :* pk-music.co.uk

PMT (Professional Music Technology): *gotta love the name.* pmtonline.co uk

Performance

The Station: *rehearsal space:* thestationbristol.org.uk

Photography

Bristol Cameras: *equipment, video, limited audio:* bristolcameras.co.uk

Clifton Cameras: cliftoncameras.co.uk

London Camera Exchange (Bristol Branch): lcegroup.co.uk

Film & Video

Spike Film & Video: *production, post-production, services, equipment hire:* spikeisland.org.uk

Geneva Stop: *film, equipment hire, stock, telecine:* genevastop.co.uk

Cine to DVD Transfer: cine-to-dvd-transfer.co.uk

Ceramics

Maze Studios: *ceramics workshop:* mazestudiosbristol.com

Printmaking

Spike Print Studios: *open-access:* spikeprintstudio.org

Transport

Minimoves: minimoves.co.uk

Restoration/Conservation

International Fine Art Conservation Studios: ifacs.co.uk

Also

Bristol Creatives: *directory:* bristolcreatives.co.uk

Good Stuff

Spike Island and Spike Island Associates: spikeisland.org.uk

Arnolfini: arnolfini.org.uk

CARDIFF

Studios
Kings Road Artist Studios: kingsroadartiststudios.wordpress.com

Bit Studios: bitstudios.wordpress.com

Oriel Canfas Studios: orielcanfas.co.uk

Inkspot: inkspotartsandcrafts.com

Butetown Artists: bayart.org.uk

Fox Studio: fox.studio.cardiff@gmail.com

Warwick Hall Studios: warwickhallstudios@gmail.com

Materials
Inkspot Arts & Crafts Centre: inkspotartsandcrafts.com

SW Reclamation Yard: rcw-reclamation.co.uk

PandP Timber: pandptimber.co.uk

P & P Supplies: *metal:* pandpsupplies.co.uk

J C Welding & Gas Supplies: jcweldingandgassupplies.co.uk

Casting
Art Specilaist foundry: in Llanrhaeadr-ym-Mochnant: bronzefoundry.co.uk

Mid-range Foundry: bcfoundry.co.uk

Cardiff School of Art

Fabricators
Amrob Engineering: *metal:* amrob.co.uk

D.B.J. Engineering Co.Ltd: coreeng.co.uk

Dipec Plastics: dipec.co.uk

Performance
Performance Wales: performance-wales.org

Trace Gallery: tracegallery.org

Film & Video
Action Video: *services:* actionvideo.org.uk

Visual Impact: *equipment hire:* virental.co.uk

Digital Images: *telecine etc.:* jsdigital-images.co.uk

Crash Editing: *hire, services:* crashediting.co.uk

Ceramics
Fireworks Clay Studios: fireworksclaystudios.org

Printmaking
Cardiff Print Workshop: *open access,* cardiffprintworkshop.com

Print Market Project: *open access, services:* printmarketproject.com

The Printhaus: *open access, services:* theprinthaus.org

V6: virtually-6.com

Photography
ffoto: ffotogallery.org

Davies Colour daviescolour.co.uk

Express Imaging: expressimaging.co.uk

Camera Centre Cardiff : cameracentreuk.com

Also
FORUM: ffotogallery-forum.blogspot.co.uk

BRG: b-r-g.org

Elbow Room: elbowroom.org.uk

Good Stuff
WARP: g39.org/warp

Artes Mundi: artesmundi.org

Chapter Arts Centre: chapter.org

BIRMINGHAM

Studios

The Lombard Method: *communal:* thelombardmethod.org

A3 Project Space and Studios: a3projectspace.org

STRYX: *artist-led studio, project and exhibition space:* stryx.co.uk

Grand Union: *gallery with small number of studios;* grand-union.org.uk

Materials

Harris Moore: *general art supplies:* hm-artsupplies.co.uk

Spectrum: *general art supplies:* spectrumfinearts.co.uk

Special Plasters: *casting/ mouldmaking materials*: specialplasters.com

Edwards Metals: edwardsmetals.co.uk

Keatley's: *non-ferrous:* johnkeatleymetals.com

FH Wardens: *steel:* fhwarden.co.uk

LA Metals: *aluminium:* lametals.co.uk

Whites: *ironmongers/hardware:* 20 Summer Lane, B19 3TS

H M Lowe: *timber:* pahillfasteners. co.uk/hmlowe

Gregory Pank: *hardware:* 86-87 Digbeth, B5 6DY

D3 Display: *acrylic/perspex:* d3display.com

Hot Glass Studio: dudley.gov.uk/ see-and-do/museums/red-house-glass-cone

Express Polythene: *packing materials:* expresspolythene.co.uk

Casting

Red Temple: *specialist art casting:* redtemple.co.uk

Lunts: *specialist art casting:* luntscastings.co.uk

Newby Foundry - *large industrial:* newbyfoundries.co.uk

CMA Mouldform: *white metals, resin:* cmamoldformltd.co.uk

Sound

SOUNDkitchen: soundkitchenuk.org

Modulate: modulate.org.uk

Audiobulb: audiobulb.com

BEAST: birmingham.ac.uk/ facilities/BEAST/about/meet-beast.aspx

Film & Video

Vivid Projects: *production, film, video:* vividprojects.org.uk

Printmaking

Birmingham Printmakers: *open access:* birminghamprintmakers. org

Mission print: *screenprint, litho, editions:* missionprint.co.uk

Performance

Fierce Festival: wearefierce.org

Photography

Matt & Pete's photo school: photo-school.co.uk

The Darkroom: *open access, services:* darkroombirmingham.co.uk

Palm Lab: palmlabs.co.uk

Kaleidoscope Imaging: kal.uk.com

Fabricators

A&S Fabrications: *brass, aluminium, steel, powder coating:* architecturalmetalwork.org

Matt Foster: *fabrication, carpentry:* plane-structure.co.uk

Avon: *metal fabrication, powdercoating:* avonstar.co.uk

Transportation
C'Art art transport specialists:
cart.uk.com

Framing
The Framers: theframers.net
Gales & Co: *high quality:*
galeandcompany.com

Also
axisweb.org/features/news-and-
views/in-focus/birmingham

Good stuff
Eastside Projects and ESP – Eastside
Projects' Associates scheme:
eastsideprojects.org
IKON: ikon-gallery.co.uk

MANCHESTER

Studios
AWOL Studios
awol-studios.co.uk
Islington Mill
islingtonmill.com
Bankley Studios and Gallery
bankley.org.uk
Mirabel Studios
mirabelstudios.co.uk
Rogue Artists Studios
rogueartistsstudios.co.uk

Hot Bed Press: hotbedpress.org
The Penthouse:
thepenthousenq.com
Masa: masa-artists.com

Materials
Fred Aldous: *general, modelling,
casting, metal, wood*:
fredaldous.co.uk
H.Blyth & Co.: *general art supplies:*
hblythco.com
Turners: *general art supplies:*
turnersartshop.co.uk
Delta Resins: deltaresins.co.uk
Jeffay Furniture: *stretchers, plinths,
crates:* artiststretcherbars.co.uk
Metal Supermarket:
metalsupermarkets.com
One Stop Metals:
onestopmetals.co.uk
Smith Metal: smithmetal.com
George Hill: *timber, free delivery:*
georgehill-timber.co.uk
Trafford Timber: *free delivery:*
trafford-timber.co.uk

Fabrication
Fab Lab Manchester: *CNC, Laser
cutting, etc:*
fablabmanchester.org

Swift: *will work with artists
on steel fabrication:*
swiftsecurityproducts.co.uk
Lost Heritage: *die-cutting, CNC,
laser cutting:* lostheritage.co.uk

Foundries
Lew: *cast iron, aluminium, bronze;
will do small batch, near
Rochdale:* lew.co.uk
Premier Castings: in Oldham:
premiercastings.co.uk
Coupe Foundry: *cast iron & steel –
do work with artists, near Preston*:
coupefoundry.co.uk

Sound
The Penthouse:
thepenthousenq.com
Manchester Digital Laboratory:
madlab.org.uk
Manchester Midi School:
midischool.com
Radio Regen: *community radio:*
radioregen.org
School of Sound Recording:
s-s-r.com
Z Arts: *studio to hire:* z-arts.org
Soundbase Megastore: *equipment:*
soundbasemegastore.com

Performance

Work for Change: *rehearsal space at The Yard:* work.change.coop

Z Arts: *dance studio hire:* z-arts.org

Photography

A Family of: afamilyof.com

Manchester Photographic: manchesterphotographic.com

Manchester Academy of Photography: manchesteracademyofphotography.co.uk

Red Eye: redeye.org.uk

Film & Video

Cornerhouse Artist Film: cornerhouse.org/artist-film

Community Arts North West (CAN) Digital Media Lab: can.uk.com

Purescreen: purescreen.co.uk

Bureau: Artists' Film & Video Collection *viewable by appointment:* bureaugallery.com

Manchester Digital Laboratory: madlab.org.uk

Ceramics

Manchester Craft and Design: craftanddesign.com

Pascal Nichols: *fabricator, courses:* pascal.nichols@yahoo.co.uk

Printmaking

Hot Bed Press: *open access: studios:* hotbedpress.org

Also

The Manchester Contemporary: Art Fair: themanchestercontemporary.com

Networking with professionals e.g. copyright lawyers: Junior Chamber International Manchester jcimanchester.org.uk

MIRIAD Art Research Centre: miriad.mmu.ac.uk/art

The Art Guide: specialises in the NW: theartguide.co.uk

Good Stuff

CG Associates: castlefieldgallery.co.uk

New Art Spaces: *run by Castlefield, provides free short term project spaces to members:* castlefieldgallery.co.uk

The Tool Kit: thetoolkit.net

Cornerhouse: cornerhouse.org

Blank Media Collective: blankmediacollective.org

LIVERPOOL

Studios

Bluecoat: thebluecoat.org.uk

The Royal Standard: the-royal-standard.com

Curve Studios: curvegallery.co.uk

Arena: arenastudiosandgallery.com

Dot Art: services.dot-art.com

Bridewell Studios: bridewellstudios.co.uk

Red Wire: 07868982066

Materials

Rennies Art and Craft: *general art supplies:* renniesartsandcrafts.co.uk

R. Jackson and Sons: *general art supplies:* rjacksonandsons.co.uk

Bluecoat Books and Arts: *general art supplies:* bluecoatbooks.co.uk

Edmund A. Stephens: *timber:* edmundastephens.co.uk

Aalco: *metal:* aalco.co.uk

Casting

Castle Fine Arts Foundry: bronzefoundry.co.uk

Merseyside Castings: *up to steel:* merseysidecastings.co.uk

Film & Video
FACT: fact.co.uk
Mersey Film Video:
 mersey-film-video.co.uk

Fabricators
Metal Man: metalmanld.com

Printmaking
Bluecoat: thebluecoat.org.uk

Also
Art in Liverpool:
 artinliverpool.com

Good Stuff
Bluecoat: thebluecoat.org.uk
They also have a Tate there..

NEWCASTLE

Studios
Baltic 39: balticmill.com/39/studios
Newbridge project
 thenewbridgeproject.com
Cobalt: 10 – 16 Boyd Street,
 Ouseburn, NE2 1AP
Lime St Studios:
 36limestreet.co.uk
Mushroom Works:
 mushroomworks.com

Materials
details: *general art supplies:*
 newcastle-arts-centre.co.uk
Robert Duncan: *timber:*
 robertduncan.co.uk
Lawson's Timber:
 lawsonstimberltd.com
James Latham: *timber:*
 lathamtimber.co.uk
Burrells: *general building supplies:*
 jamesburrell.com
Amari: *plastics:*
 amariplastics.com
Whaleys Bradford: *fabric specialists:*
 whaleys-bradford.ltd.uk
Metal Supermarket:
 metalsupermarkets.com
Simpsons packaging:
 simpson-packaging.co.uk

Casting
William Lane: *in Middlesborough:*
 williamlane.co.uk
*Also Newcastle and Northumbria
Universities*

Ceramics
Spencroft ceramics:
 spencroftceramics.co.uk

Sound
Modular: modular.org.uk
Trigger Shift: triggershift.org

Film & Video
R&B Group: *AV hire:*
 rbgroup.co.uk
ArtAV: artav.co.uk
Three-16 Productions: *AV hire:*
 three-16productions.com
Culture Lab Newcastle University:
 ncl.ac.uk/culturelab
Isis Arts: *residencies, support:*
 isisarts.org.uk
Folly: *residencies, workshops:*
 folly.co.uk

Performance
Platform North East:
 platformnortheast.org

Printmaking
Northern Print Studio: *open access,
 services:* northernprint.org.uk

Photography
Woodhorn Museum and
 Northumberland Archives:
 printing:
 experiencewoodhorn.com
Ben Young: *documentation services:*
 ben.young@network.rca.ac.uk
Colin Davison: *documentation
 services:* rosellastudios.com

Fabricators

North Exhibition Services: *fabrication and tech:* northexhibitionservices.com

Craig Knowles: *blacksmith:* ckab.co.uk

RASKL: *joinery:* raskl.co.uk

Bay Plastics: bayplastics.co.uk

Transportation

Arterium Leeds: arterium.co.uk

Framing

Gallagher & Turner: gallagherandturner.co.uk

Factory Framing factoryframingcentre.co.uk

Conservation

Alisa Vincentelli: uk.linkedin.com/ pub/alisa-vincentelli/19/354/b73

Good Stuff

The Baltic and Baltic 39: balticmill.com

GLASGOW

Studios

SWG3: swg3.tv

Glasgow Independent Studio: gis.uk.com

Glasgow Sculpture Studios: glasgowsculpturestudios.org

Southside Studios: southsidestudios.org

Southblock: southblock.co.uk/studios

Wasps: *various around the city:* waspsstudios.org.uk

GAS: ga-studios.co.uk

The Hidden Lane: facebook.com/thehiddenlane

Materials

The Art Store: *general art supplies:* artstore.co.uk

Art Mediums: *general art supplies:* artmediums.co.uk

Timber and Plywood: *supplies, machining:* timberplywood.com

MGM Timber: mgmtimber.co.uk

Righton: *metals and plastics:* righton.co.uk

Aalco: *metal:* aalco.co.uk

Casting

Archibald Young: archibaldyoung.co.uk

George Taylor and Co.: *cast iron, not art specialist but will do 'miscellaneous':* gtham.co.uk

Sound

The Glue Factory: *equipment, space, services:* thegluefactory.org

CAVA: cavasound.com

Jack Coghill: elevator-audio.tv

Chem19: chem19.co.uk

Wet Sounds: wetsounds.co.uk

Cryptic Associates: cryptic.org.uk/cryptic-associates

The Warehouse: *sound hire:* warehousesound.co.uk

Film & Video

GMac: *great equipment hire rates for members:* gmacfilm.com

Black Light: *AV equipment for sale:* black-light.com

Panalux: panalux.biz

Camcorder Guerillas: *film collective, workshops:* camcorderguerillas. wordpress.com

Luke Collins: *digital, production, editing:* oscarbox.org/digital

Rob Kennedy: *installation, editing:* robkenn@gmail.com

Ceramics

Glasgow Ceramics Studios: *classes, firing services, kiln hire:* glasgowceramicstudio.com

Fireworks Studio Pottery: *open access or monthly studio:* fireworkspots.com

Glasgow Sculpture Studios:
has ceramics workshop:
glasgowsculpturestudios.org

Printmaking

Glasgow Print Studio: *open access:*
gpsart.co.uk
Bespoke Atelier: *print room to hire:*
thegluefactory.org

Photography

Alan Dimmick:
dimmickalan@hotmail.com

Fabricators

Flux Laser Studios: *laser cutting,
engraving:* fluxlaserstudio.co.uk
Stephen Murray: *timber-
based solutions:*
stephenhodsdenmurray@gmail.
com
MARTHA: *fabrication:*
robkenn@gmail.com
Glasgow Sculpture Studios:
*brilliant wood, metal
and ceramics workshops:*
glasgowsculpturestudios.org

Transportation

Constantine: *specialist fine art:*
constantinemoving.com
Mail Box Etc.: *not specialist but
pretty good:* mbe.co.uk

Also

Scottish Artists Union:
sau.org.uk
Creative Scotland:
creativescotland.com
The Visual Arts Studio:
visualartsstudio.co.uk

Good Stuff

Tramway: *just go there:*
tramway.org
CCA: Centre for Contemporary Art:
cca-glasgow.com

UK & GENERAL

Studio Organisation

National Federation of Artists'
Studio Providers: nfasp.org.uk

Performance

Live Art UK: liveartuk.org

Digital Media etc.

Furtherfield: furtherfield.org
Digital Arts Development Agency:
da2.org.uk
Sound Toys: soundtoys.net
Public Art think tank: ixia-info.com

Film & Video

Frameworks: *forum:*
hi-beam.net/fw.html

Artists Moving Image Research
Network:
movingimagenetwork.co.uk
Art Player: artplayer.tv
Database: cinovid.org
Tank.TV: tank.tv
Videoclub: videoclub.org.uk
AP Engine: apengine.org
Vimeo's Video School:
vimeo.com/videoschool

Materials/ Equipment

Special Plasters: *casting powders:*
specialplasters.co.uk
Silverprint: *photographic supplies:*
silverprint.co.uk
AV Equipment Hire:
fact.co.uk/services/equipment-
hire-installations

Ceramics Supplies

Potclays: potclays.co.uk
Pottery Crafts: *glazes:*
potterycrafts.co.uk
Cromartie: *kilns, tech support*
cromartiehobbycraft.co.uk
Valentines: *clay:*
valentineclays.co.uk
Northern Kilns:
northernkilns.com/shop/2
Bath Potters' Supplies:
bathpotters.co.uk

Ceramic Digital: *transfers:*
ceramicdigital.co.uk

Heraldic Pottery: *transfers:*
heraldicpottery.co.uk

Ed Bentley: *fabricator:*
edbentley.co.uk

Woodworking
woodworking.co.uk

Transport
Isler & Isler: *collective shipments to Europe:* isler-isler.ch
Juicy Lucy: *to Europe:*
juicy-lucy.org

Conservation
Institute of Conservation Register:
conservationregister.com

Independent Art Schools
Open School East:
openschooleast.org
The School of the Damned:
theschoolofthedamned.com
The Public School London:
thepublicschool.org/london
LuckyPDF Global School of Art:
luckypdf.com

MISCELLANY

UbuWeb: *great stuff:*
ubuweb.tv
Starting a radio station:
communityradiotoolkit.net
Film-makers' Co-op (New York):
film-makerscoop.com
Lightcone Experimental
Film: lightcone.org/en
Experimental Television Center
(USA): experimentaltvcenter.org
Anthology Film Archives:
anthologyfilmarchives.org
Rewind Artists Video: rewind.ac.uk
Canyon Cinema
(USA): canyoncinema.com
Field Recording Radio:
frameworkradio.net
Cathedral of Shit: *archive:*
cathedralofshit.wordpress.com
This is Tomorrow: *online art magazine:* thisistomorrow.info
AAAARG.ORG: aaaarg.org
e-flux: e-flux.com

NOTES